Available soon:

For more information visit our web site

www.oup.co.uk/vsi

Art History: A Very Short Introduction

'arguably the most intelligent introduction to the study of the history
of art available today. Accessibly and persuasively written, the author
lucidly outlines the variety of interpretative strategies that
currently animate the discipline . . . a lively as well as thoughtful
introduction to this field.'
Professor Keith Moxey
Ann Whitney Olin Professor of Art History at Barnard College
and Columbia University

'an approachable and lucid overview, not of the history of art, but of
the issues and debates within the discipline of art history. Arnold's
strategy is to wrap ideas around concrete examples. By directing us
to look at particular works of art, she teaches us to see them with
an art historian's eyes.'
Margaret Iversen, Professor of Art History and Theory,
University of Essex

VERY SHORT INTRODUCTIONS are for anyone wanting a stimulating and accessible way in to a new subject. They are written by experts, and have been published in more than 25 languages worldwide.

The series began in 1995, and now represents a wide variety of topics in history, philosophy, religion, science, and the humanities. Over the next few years it will grow to a library of around 200 volumes – a Very Short Introduction to everything from ancient Egypt and Indian philosophy to conceptual art and cosmology.

Very Short Introductions available now:

ANCIENT PHILOSOPHY
 Julia Annas
THE ANGLO-SAXON AGE
 John Blair
ANIMAL RIGHTS David DeGrazia
ARCHAEOLOGY Paul Bahn
ARCHITECTURE
 Andrew Ballantyne
ARISTOTLE Jonathan Barnes
ART HISTORY Dana Arnold
ART THEORY Cynthia Freeland
THE HISTORY OF
 ASTRONOMY Michael Hoskin
ATHEISM Julian Baggini
AUGUSTINE Henry Chadwick
BARTHES Jonathan Culler
THE BIBLE John Riches
BRITISH POLITICS
 Anthony Wright
BUDDHA Michael Carrithers
BUDDHISM Damien Keown
CAPITALISM James Fulcher
THE CELTS Barry Cunliffe
CHOICE THEORY
 Michael Allingham
CHRISTIAN ART Beth Williamson
CLASSICS Mary Beard and
 John Henderson
CLAUSEWITZ Michael Howard
THE COLD WAR
 Robert McMahon

CONTINENTAL PHILOSOPHY
 Simon Critchley
COSMOLOGY Peter Coles
CRYPTOGRAPHY
 Fred Piper and Sean Murphy
DADA AND SURREALISM
 David Hopkins
DARWIN Jonathan Howard
DEMOCRACY Bernard Crick
DESCARTES Tom Sorell
DRUGS Leslie Iversen
THE EARTH Martin Redfern
EGYPTIAN MYTHOLOGY
 Geraldine Pinch
EIGHTEENTH-CENTURY
 BRITAIN Paul Langford
THE ELEMENTS Philip Ball
EMOTION Dylan Evans
EMPIRE Stephen Howe
ENGELS Terrell Carver
ETHICS Simon Blackburn
THE EUROPEAN UNION
 John Pinder
EVOLUTION
 Brian and Deborah Charlesworth
FASCISM Kevin Passmore
THE FRENCH REVOLUTION
 William Doyle
FREUD Anthony Storr
GALILEO Stillman Drake
GANDHI Bhikhu Parekh

Dana Arnold

ART HISTORY

A Very Short Introduction

OXFORD
UNIVERSITY PRESS

OXFORD
UNIVERSITY PRESS

Great Clarendon Street, Oxford OX2 6DP

Oxford University Press is a department of the University of Oxford.
It furthers the University's objective of excellence in research, scholarship,
and education by publishing worldwide in

Oxford New York

Auckland Bangkok Buenos Aires Cape Town Chennai
Dar es Salaam Delhi Hong Kong Istanbul Karachi Kolkata
Kuala Lumpur Madrid Melbourne Mexico City Mumbai Nairobi
São Paulo Shanghai Taipei Tokyo Toronto

Oxford is a registered trade mark of Oxford University Press
in the UK and in certain other countries

Published in the United States
by Oxford University Press Inc., New York

© Dana Arnold 2004

British Library Cataloguing in Publication Data

Data available

Library of Congress Cataloging in Publication Data

Arnold, Dana.
Art History: a very short introduction/Dana Arnold.
p. cm.
Includes bibliographical references and index.

1. Art. 2. Art history. I. Title.
N7425.A646 2004
709—dc22 2004041451

ISBN 978-0-19-280181-4

9 10

Typeset by RefineCatch Ltd, Bungay, Suffolk
Printed in Great Britain by
Ashford Colour Press Ltd, Gosport, Hants.

Contents

Acknowledgements

The opportunity to write this Very Short Introduction came as my term as editor of the journal *Art History* was coming to a close. Writing an introduction to the discipline that I had been so closely involved with in all its complexities, and which spreads beyond the purview of this volume, seemed to be a most appropriate way of summing up some of the ways in which art history has developed in recent years as well as identifying new directions in the study of art. This brief volume covers the broadest possible spectrum of the art we might expect to see in galleries and museums. As such the choices I had to make in terms of the approach, material covered and which illustrations to use were the most enjoyable and difficult parts of writing this book. I was fortunate to be inspired and encouraged by many in the preparation of this volume and, although any omissions or errors are my own, I would like to thank Adrian Rifkin, my co-editor of *Art History*, for providing such a stimulating and collegial working environment during our editorship. I am also indebted to Kate Nicholson, Yvonne Young, Hannah Young McHugh and Ken Haynes for their comments and suggestions on my choice of illustrations and to Julie Schlarman for compiling the index. The final draft of this VSI was written during my tenure as a Visiting Scholar at the Getty Research Institute in Los Angeles and I would like to thank the Getty staff, my research assistant Emily Scott and my fellow scholars for providing such a welcoming academic environment in which to finish the text.

Dana Arn
London,

Preface

This book is intended as an introduction to the issues and debates that
make up the discipline of art history and that arise from art history's
central concerns – identifying, categorizing, interpreting, describing,
and thinking about works of art. The ways in which art history has
approached these tasks has changed over time. These shifting attitudes
towards the parameters of art history, and how histories can interrogate
visual subject matter, have raised questions about the presentation of
the history of visual art in written form and the limits verbal language
has placed on our ability to do this. In recent years the relative
importance of the role of the artist, the subject, and the viewer in the
artistic enterprise have also been re-evaluated. These issues in turn raise
questions to do with our preoccupation with authorship, authenticity,
and chronologically defined linear progression, all of which have
informed the traditional canon of art history, which may be only one
way of looking at, analysing, and historicizing art.

Thus, traditional histories of art emphasize periods and styles, and focus
on Western artistic production, and this can obscure other approaches,
for instance the grouping of artworks according to their subject matter,
or influence the way in which arts from non-Western cultures are
discussed. This book challenges such traditional ways of seeing and
writing about art. I have, therefore, chosen examples from different
historical moments and cultures to illustrate questions that I see as
fundamental to the subject. This being a Very Short Introduction, I have

been selective in my choice of illustrations, and the images I use are meant only to be indicative of the issues I discuss in relation to them. As a whole, the illustrations are representative of 'high art', that is to say the art we expect to find in museums and galleries. This material enables us to investigate a range of social and cultural issues covered by art history.

I begin with a consideration of the fundamental question 'what is art history?' This enables me to draw distinctions between art history and art appreciation and art criticism, and to consider a range of artefacts included in the discipline and how these have changed over time. Although art is a visual subject, we learn about it through reading and we convey our ideas about it mostly in writing. This sets off an interplay between the verbal and the visual which I explore in Chapter 2. Here, I look at how histories of art have been written and the effect that this has had on the object itself and on the subjects of art history. Examples from a broad time span are used, including Pliny, Vasari, and Winckelmann, together with more recent writings by Gombrich, Greenberg, Nochlin, and Pollock. A discussion of these writers introduces the expectations we have of art history as a chronological story about great Western male artists. The bias in this interpretation of the subject opens up the questions of the importance of the canon in art history and how we view non-figurative, primitive, and naïve art.

The importance of the gallery or museum – or more generally of ways of presenting art history – is covered in Chapter 3, which maps out the development of collections from cabinet of curiosities to the private and corporate sponsor and collector of today. Alongside this, I discuss the impact the amassing of objects has had on their perceived value and on the histories of art, and how writing about objects can affect their 'value'. The question of the canon of art history returns in this chapter in relation to the ability of the gallery or museum either to endorse or to challenge it. I look at this with special reference to the importance of the identity of the artist in gallery display and in answer to the question 'what difference does it make to the presentation of art history if art is presented to the public as a thematic exploration of a subject or as a

chronological sequence?' This also informs my consideration of how 'blockbuster' exhibitions have changed the direction of art history, for instance the Post-Impressionism exhibition of 1912 that gave that art movement its name.

The relationship between art and thought can be a complex one, and in Chapter 4 I discuss the impact various philosophical schools and psychoanalytic theory have had on the way in which we think about art history and the role, meaning, and interpretation of art. I introduce the ideas of such key thinkers as Hegel, Marx, Freud, Foucault, and Derrida in order to show how they have interacted with art history, not least in regard to the emergence of social histories of art and feminist art history. Chapter 5 goes on to discuss the idea of meaning in art, in particular of the quality and kinds of representation, and the use of iconography, or symbolism, in artworks throughout history. In Chapter 6 I look at the different media and techniques used to produce art.

As well as introducing ways to think about art and its history, I hope this book will encourage and enable the enjoyment and understanding of artworks themselves, and I want at all times to reinforce the importance of the art object as our primary evidence, or starting point, for art history. To this end, the final chapter brings us back to the work itself. I draw attention to ways in which we might read the physicality of the object in terms of the technique and medium used to create it, as well as other methods we might employ for reading the visual.

This book is intended to be of interest to the general reader, the gallery-goer, the A-level student, and as a grounding in aspects of visual culture for first-year undergraduates studying art history, archaeology, and cultural studies. I have aimed to write the text without using jargon, but there are a number of technical and specialist terms that are essential to use and to recognize. Mindful of this, and the introductory nature of this book, I have included a full glossary of terms and a list of website addresses for galleries and museums, which provide a starting point

for individual enquiry into works of art and the collections in which they are held.

It is my intention to give a clear, concise discussion of the complex debates within art history. I also want to equip the reader with the basic tools necessary for the study of the subject through a chronological and thematic coverage of a broad range of issues connected with the disipline. But, most importantly, this book is an attempt to convey how much we can learn from art and to suggest a diversity of ways in which we can enjoy looking at it, thinking about it, and understanding its relationship to ourselves.

List of illustrations

The publisher and the author apologize for any errors or omissions
in the above list. If contacted they will be pleased to rectify these at
the earliest opportunity.

To P.H.A.

Chapter 1
What is art history?

A thing of beauty is a joy forever

Keats

Can art have a history? We think about art as being timeless, the
'beauty' of its appearance having meaning, significance, and appeal
to humankind across the ages. At least this usually applies to our
ideas about 'high', or fine, art, in other words painting and
sculpture. This kind of visual material can have an autonomous
existence – we can enjoy looking at it for its own sake, independent
of any knowledge of its context, although of course viewers from
different time periods or cultures may see the same object in
contrasting ways.

Art appreciation and criticism

When we look at a painting or sculpture, we often ask the following
questions: who made it?; what is the subject?; when was it
completed? These are quite valid questions that are often
anticipated and answered in, for example, the captions to
illustrations in art books and the labels to works displayed in
museums and galleries. For many of us these pieces of information
are sufficient. Our curiosity about the who, what, and when of art is
satisfied and we can get on with appreciating the artwork, or just
enjoying looking at it. For those of us also interested in how,

information on the technique used – for instance, oil or tempera (see Chapter 6) – might help us to appreciate further the skill of the artist. The important thing to note about this kind of art appreciation is that it requires no knowledge of art history. The history of an individual work is contained within itself and can be found in the answers to the questions who, what, when, and how. These are the kinds of details that appear in catalogues of museum and gallery collections or those produced for art sales, where perhaps information about the original patron (if relevant) might also answer the question why. Auction houses, museums, and galleries also place emphasis on the provenance of a work of art. This is the history of who has owned it and in which collections it has been held. This acts as a kind of pedigree for the work and might be used to help prove that it is an authentic work by a given artist. All this information is important in determining the monetary value of a painting or sculpture but need not necessarily be important for art history.

In this way, art appreciation requires no knowledge of the context of art; the 'I know what I like and I like what I see' approach to gallery-going is sufficient. And this is absolutely fine. We can enjoy looking at something just for what it is and art can become absorbed into what might be called popular culture.

Art appreciation can also involve the more demanding process of criticizing the art object on the basis of its aesthetic merits. Usually aspects such as style, composition, and colour are referred to, and more broadly reference is made to the artist's other work, if known, or to other artists working at the same time or within the same movement or style.

Connoisseurship

Art appreciation and criticism are also linked to connoisseurship. By its very name this implies something far more elitist than just enjoying looking at art. A connoisseur is someone who has a

specialist knowledge or training in a particular field of the fine or decorative arts. The specialist connoisseur may work for an auction house – we have all seen how on television programmes such as the *Antiques Roadshow* experts are able to identify and value all manner of objects, not just paintings, on the basis of looking at them closely and asking only very few questions of the owner. This kind of art appreciation is linked to the art market and involves being able to recognize the work of individual artists as this has a direct effect on the work's monetary value.

Another aspect of connoisseurship is its relationship to our understanding of taste. A connoisseur's taste in relation to art is considered to be refined and discriminating. Our concept of taste in relation to art is quite complicated, and inevitably it is bound up in our ideas about social class. Let me take a little time to explore this more fully. I have already discussed the practice of art appreciation – art available for all and seen and enjoyed by all. By contrast, connoisseurship imposes a kind of hierarchy of taste. The meaning of taste here is a combination of two definitions of the word: our faculty of making discerning judgements in aesthetic matters, and our sense of what is proper and socially acceptable. But by these definitions taste is both culturally and socially determined, so that what is considered aesthetically 'good' and socially 'acceptable' differs from one culture or society to another. The fact that our taste is culturally determined is something of which we have to be aware, and this crops up throughout this book. Here, though, it is important to think about the social dimension of taste as having more to do with art as a process of social exclusion – we are meant to feel intimidated if we don't know who the artist is, or worse still if we don't feel emotionally moved through the 'exquisiteness' of the work. We have all read or heard the unmistakable utterances of these connoisseurs. But luckily their world does not belong to art history. Instead, art history is an open subject available to everyone with an interest in looking at, thinking about, and understanding the visual. It is my intention in this book to describe how we can engage with art in these ways.

History as progression

For art to have a history we expect not only a timeless quality but also some kind of sequence or progression, as this is what history leads us to expect. Our history books are full of events in the past that are presented as part of either the continual movement towards improvement, or as stories about great men, or as epochs of time that stand out from others – for instance, the Italian Renaissance or the Enlightenment. In regard to these kinds of frameworks for thinking about the past, the history of art does not disappoint. In the coming together of these two separate strands, we see how history reorders visual experience, making it take a range of forms. The most popular of these include writing about the history of art from the point of view of artists – usually 'great men'. Alternatively, we find art historians have sought to define the great stylistic epochs in the history of art, for example the Renaissance, Baroque, or Post-Impressionism. Each of these traditions can be written about independently of the others and they have provided a backbone for histories of art. Here I use the plural since the results of each of these ways of writing about the history of art are different, placing different emphasis on what is important – in some cases the artist, in others the work or the movement to which the work belongs.

The problem with concentrating on formal elements such as style is that style itself becomes the subject of discussion rather than the works of art. As we become preoccupied with marking out stylistic changes, we have to use our knowledge of what came after the work under discussion. The benefit of hindsight is essential here – how else could we know that the beginnings of an interest in nature and naturalism in the art of Early Renaissance Italy prefigured the consummate achievements of artists of the High Renaissance in this regard? Working backwards from the present imposes a line of development of which the outcome is already known. In this way, tracks or routes through the art of the past can favour certain styles – this is certainly the case with classical art and its reinterpretations.

Also, histories of art that focus solely on style can easily neglect other aspects of an artwork such as its subject matter or its function. It is possible to narrate a history of artistic style using representations of the male and female body. This might begin with the representation of physical perfection achieved in ancient times by the Greeks. By the Middle Ages, however, there was little interest in the naturalistic depiction of the human form. But by the Renaissance period increased knowledge of human anatomy and nature meant that art had become more 'life-like'. But this kind of history could also be told using representations of cats and dogs, although most would agree that domestic pets have not been a principal focus for artists over the last two millennia.

Yet style has played a significant role in the formulation of histories of art, and it is only in recent years that the notion of stylistic progress in Western art has been reassessed. Indeed, the emphasis on style leads us to expect the notion of progression and constant development in art. If we want art to represent the world we think we see, then we can impose an expectation of a continual move towards naturalism. But how do we then think about art that is not interested in naturalistic representation? This kind of abstract or conceptual art can be sidelined and deemed of secondary importance – sometimes it is labelled 'primitive' or 'naïve' art, with a pejorative air. In many ways modern art confronts this prejudice, but often provokes cries of 'is it art?'.

In the case of biographical histories, we look for evidence of youth, maturity, and old age in the work of an artist. This works quite well if the artist lived for a long time, but an untimely death does not lend itself to this kind of narrative arch. Claude Monet's (1840–1926) early work *The Poppy Field* (1873) differs from the cycles of pictures of the same object at various times of day he produced in the 1880s and 1890s, as seen in his views of *Rouen Cathedral* (1894; Fig. 1) or *Haystacks* (1891). But although we can see similar preoccupations in the interest in light, shade, and colour as a way of modelling form, these phases of Monet's career stand distinct from

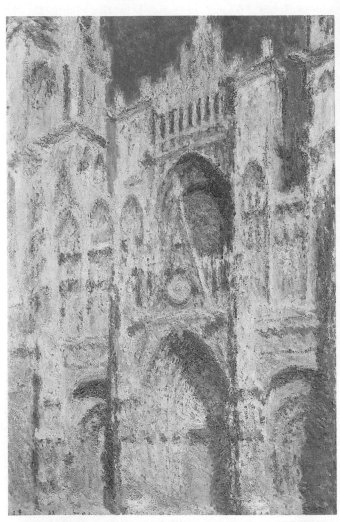

1. *Rouen Cathedral: The Portal (in Sun)* by Claude Monet (1894).

his late works, such as the large-scale paintings of the lily ponds at his Japanese-style garden at Giverny. This kind of biographical approach isolates the artist from their historical context. We often forget that Monet's late works were painted in the early 20th century – at the same time as Picasso was experimenting with Cubism.

Is there then a distinction to be made between the interaction of art and history, and art history? That is to say that histories of art can have a single focus on style or the work in relation to the biography of the artist, where our expectations of a progressive history are inflicted on the visual. What I am suggesting here is that we turn the question on its head and put art in the driving seat, so to speak. By using art as our starting point we can see the complex and intertwined strands that make up art history. This implies that art history is a subject or academic field of enquiry in its own right, rather than the result of the rules of one discipline being applied to another. I return to this point on a regular basis in this book. I aim to set out how histories of art have been constructed, to describe the ways in which we have been encouraged to think about art as a result, and also to introduce other ways of thinking about the visual in terms of its history.

Evidence and analysis in art history

It is important to discuss what kind of archive art history can draw upon, as the range of material used to construct these histories extends well beyond the works themselves. For instance, history has its documents, written records of the past; archaeology focuses on the material record, physical remains of the past; whilst anthropology looks to social rituals and cultural practices as a way of understanding past and present peoples. Art history can draw upon all these archives in addition to the primary archive of the artwork. In this way, art history is the stepping stone into various ways of interpreting and understanding the past.

In contradiction to this, what is known as the 'canon' of art regiments our understanding and interpretation of the evidence. In this instance, the canon is artwork regarded by influential individuals – not least connoisseurs – as being of the highest quality. In art history the canon has usually, but not exclusively, been associated with the 'traditional' values of art. In this way the canon plays an important role in the institutionalization of art, as new works can be judged against it. As such it is a means of imposing hierarchical relationships on groups of objects. This hierarchy usually favours the individual genius and the idea of the 'masterpiece'. Moreover, the canon promotes the idea that certain cultural objects or styles of art have more value (both historical and monetary) than others. One of my principal interests in this book is the impact of canonical works that are considered defining examples of taste and of historical significance on art history.

I have been using the words 'art' and 'visual' almost interchangeably. This raises another important question – what are the subjects of art history? Traditionally, the history of art has been concerned with 'high art'. But a range of artefacts has been included in the discipline, and these have changed over time. When talking about the Renaissance, for instance, it is quite easy to confine discussion to known artists such as Michelangelo or Raphael and to works of painting or sculpture, or their preparatory processes such as drawings. But the remains of the visual outputs of different cultures and epochs are quite varied and invite a range of interpretations. We are all familiar with the rock art of prehistoric times, but the reasons behind its production and who produced it remain enigmatic. We look at the cave paintings at Lascaux in the Dordogne, France, and see in them hunting scenes – depictions of everyday life. But rock art also includes abstract designs and shapes. So could this kind of art have had a more mystical function? Some argue that these images are the work of shamans – members of a religious cult who used hallucinogenic drugs as part of their practice of worship – and these images come from the unconscious as a result.

A different question arises if we look at ancient Greece. The world inhabited by this civilization is seen as a high point in the history of art. But most ancient Greek sculpture is known only through Roman copies, a problem discussed in more detail later on in this volume. And we have very little knowledge of ancient Greek paintings. Partly in response to these gaps in our knowledge, attention has focused on Greek vases, which even from as early as 800 BCE were decorated. The plentiful remains of Greek vases demonstrate a range of painting styles from the geometric designs of the Archaic period through to the silhouette-like bodies on Black Figure vases and the more painterly, fluid representations of the human form on Red Figure vases. These relics from the past are everyday objects, yet, perhaps due to the paucity of specimens of high art, they are venerated examples of ancient Greek art. Perhaps unsurprisingly, their history is mapped against that of Greek sculpture and is the story of ongoing development in the pursuit of the representation of human physical perfection.

In the case of non-Western art, everyday objects, sometimes referred to as material culture, are the best evidence we have for the artistic output of a given society. A Mayan vase (Fig. 2) may well tell us something about the religious or social rituals, as well as indicate the way in which artists chose to represent their world. However, in later periods in Western art, vases – and other everyday objects – have not always enjoyed such attention. Even the exquisite designs on the soft paste porcelain of the Sèvres factory or the classical scenes on Wedgwood vases take second place to the high art of the same period – at least as far as art historians are concerned. It is important to remember, however, that ceramics and furniture were often considered more valuable and prestigious possessions at the time of their production than were painting or sculpture. So the emphasis and value we place on high art may in fact misrepresent its significance in the eyes of contemporaries. And the way in which art history can distort objects in terms of their contemporary and present-day meaning

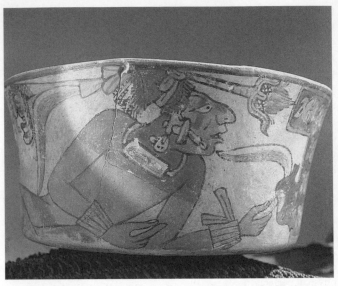

2. Mayan cylindrical vessel decorated with the image of a dignitary wearing a blossom headdress.

and significance is something I return to at various points in this book.

In recent years the term art history has itself come under question. The so-called New Art History, now a generation old, sought to reassess the way in which we think and write about histories of visual objects. New Art History was particularly influenced by theoretical ways of thinking about art to bring out its social, cultural, and historical meaning. I discuss the various ways of writing and thinking about art history in subsequent chapters; it is enough to say here that the notion of works of art having historical meaning beyond their role in the narrative of the work of great artists or of styles of art was revolutionary. So much so that the subject is still divided between 'new' and 'old' even 20 years later.

This book does not advocate either way of thinking about art

history. I see the merit of both approaches, and I very much want to question the object, confront it, in order to explore its broadest possible meaning and significance. But at the same time I do not want to lose sight of the object itself – its physical properties, and in many cases its sheer aesthetic appeal. After all, I am arguing that art history is a separate discipline from history – the visual is then its primary material, the starting point for any kind of historical enquiry. Although it is important to be able to articulate the appearance of a work of art, to describe and analyse the visual using words is not an end in itself. And making this kind of visual analysis is not always as easy as it sounds. Art history has its own vocabulary, or taxonomic system, that enables us to speak precisely about the objects we see in front of us, as can be appreciated from the glossary at the end of this book. But the ability to discuss or analyse a work of art, even using a sophisticated taxonomic system, is not art history. Certainly, it is the act of accurately describing a work, and this process may be intertwined with the practice of connoisseurship, but this satisfaction with articulating what is in front of us remains largely the preserve of art appreciation. If we compare this practice to the study of English literature, for instance, the point becomes clearer. We would neither consider reading out the text of *King Lear*, nor a synopsis of the plot of the play, the definitive analysis of this work by Shakespeare. It may be that these processes are a necessary part of the analysis, but they are not an end in themselves. Similarly, we should not accept the description of an artwork as the end of the process of study.

It is true that there is a difficulty in this relationship between the verbal and the visual; they are both discrete methods of description. This tension is further explored in the next chapter. We are perhaps more familiar with the use of words to describe art, where one system of articulation is brought to bear on the other. But we must remember that this also works the other way around – the visual can describe and represent the verbal, phenomena usually expressed in words.

Art history and 'visual culture'

More recently, the terms 'visual culture' or 'visual studies' have been used in the place of 'art history'. On the one hand this broader title acknowledges the wide range of material that can be used in historical analysis and encourages the inclusion of media like film, photography, video, and digital recording. Perhaps more importantly in this context, the field of intellectual enquiry known as visual culture takes as its subject vision and its representations. As such, visual observation and articulation is privileged over the verbal. Visual culture is partly about the physiological processes of seeing and also the nature of perception, which is to some extent culturally determined. In recent years some of these ideas have been absorbed into the discipline of art history, and I discuss these in Chapter 4.

Many of the subjects of visual culture are the same as those of art history; for instance issues of gender and a consideration of art as a system of viewing the world. The essential difference between the two disciplines arises from the fact that visual culture is concerned with the operations of the eye, and as such its archive is everything we see – the world we perceive around us; visual culture has moved beyond the scope of 'art' as traditionally conceived to incorporate the idea of movement, light, and speed in every kind of visual phenomenon from advertising to virtual reality, with an emphasis on the everyday. I am not denying the importance of these images, nor their widespread appeal. I would even venture to suggest that Mario of *The Super Mario Brothers* (Fig. 3) is as familiar as *The Mona Lisa* – if not more so to certain generations. It is also important here to distinguish between visual culture and popular culture. Art can become popular culture – not just in the way I have already discussed, but also through its adoption into other formats. Take John Constable's *The Cornfield* (1826; Fig. 4). A recent exhibition of this work held at the National Gallery in London showed how this revered image of the English countryside has been used on a range of items such as

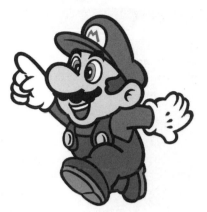

3. Mario of _The Super Mario Brothers_, one of the characters in a video game produced by Nintendo.

biscuit tins and calendars, as well as for posters and prints. In this way, visual culture can be said to encompass a broad range of subject matter that stands outside the definition of high art. Indeed, although visual culture and its methods are principally associated with more recent artistic production – in the broadest sense – its approach is an equally effective way of interrogating the artefacts from earlier periods. For instance, the distinctive category of fine art cannot necessarily be used to describe many objects that were produced in the Middle Ages. So there is a resonance between those who look at visual culture in the periods that stand on either side of the dominance of fine, or high, art in Western culture.

There is also a political dimension to visual culture as a method of critical activity, as it is seen by many of its apologists as a way in which the forces of global capitalism can be challenged. Through the emphasis on the everyday, mass consumption, and experience visual culture does concentrate mainly on the study of modernity – in this case the world in the post-World War II era. As such, its purview is based partly on the material available. We know much

13

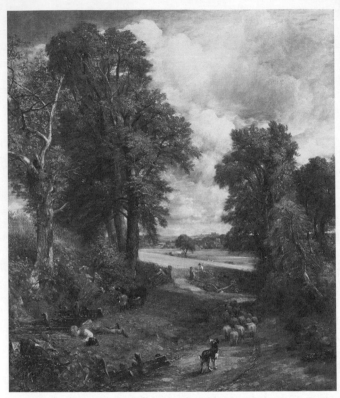

4. John Constable's painting of *The Cornfield* (1826) has adorned a range of products from calendars to biscuit tins.

less about popular culture and ways in which visual objects were perceived in earlier historical periods, so a political reading of them is more difficult to achieve. That said, many art historians do bring a political agenda to their writing, and this is discussed later in this volume.

Not all the concerns of visual culture are rooted in the later 20th century and thereafter. For instance, the concern with the way we see relates to theories of optics, which were certainly popular in

the 16th and 17th centuries and were elucidated by such prominent figures as Sir Isaac Newton and René Descartes. Optical theory found its way into artistic practice through the use of the camera obscura. Also, we must not forget the discovery of perspective in the Renaissance period in northern Europe as well as in Italy (I discuss this in Chapter 5). This shows that artists had an interest in the perception of space created by the illusory properties of linear perspective and aerial perspective. As discussed in Chapter 4, the status of visual experience was a major preoccupation of 18th-century thinkers – not least Immanuel Kant. So it is partly the political agenda of visual culture, and partly the way in which it puts the aesthetic in second place to this, as well as the broad range of artistic outputs covered, that separates this discipline from art history. Visual culture is perhaps most at home in an analysis of global capitalism as expressed in a multi-media world, and this is really the subject of a separate Very Short Introduction.

Practising art history

I want now to present some examples of the ways in which art history articulates and investigates a whole range of social and cultural issues and of the various functions art history has. In order to do this I have chosen four quite different images in terms of their subject matter and date. The first is Gentile da Fabriano's *Adoration of the Magi* (Fig. 5), also known as the *Strozzi Altarpiece*. The painting is now in the Uffizi Gallery in Florence, but originally it was an altarpiece in the Strozzi family chapel in Santa Trinità, Florence. This relocation of the picture raises an important issue when looking at works of art – quite often they are no longer in their original location, and we see them as part of a historical sequence presented by a gallery. Usually the different rooms of a gallery follow a chronological sequence, perhaps subdivided into categories, styles, or subject matter. So our primary evidence for art history – the work itself – is presented out of its original context. Looking at a work of art in a gallery can place emphasis on the

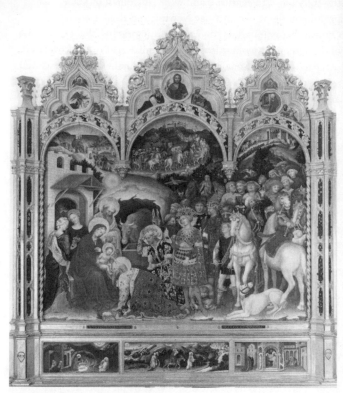

5. *The Adoration of the Magi* by Gentile da Fabriano (1423) is also known as the *Strozzi Altarpiece*. It was originally located in the Strozzi family chapel in Santa Trinità, Florence.

physical characteristics of the work itself, which harks back to the principles behind art connoisseurship I discussed earlier in this chapter.

The second issue this picture raises is the idea of the patron – the painting has two titles: one describes the subject matter, the other refers to the family who commissioned it. Interestingly, in this case the artist comes a distinct third, showing how less famous artists

can be sidelined as other preoccupations in the writing of art history come to the fore. The close relationship between the patron and the painting might lead us to question what this image was for. The subject matter – the adoration of the Magi, where three kings come to pay tribute to the infant Jesus – is based on the New Testament of the Bible and is an important moment in the Christian faith. Gentile's image captures this moment, as the kings kneel to show their respect to the Christ child, which is meant to underscore their recognition of Jesus as the presence of God on earth. Indeed, most of the art produced in the West in the Middle Ages was religious – comprising altarpieces and fresco decorations in chapels, as well as intricate manuscript illustrations. Although the work dates from the Early Renaissance, Gentile shows an affinity with these older traditions in his style and materials, which implies there are not such clear breaks between one artistic period and the next.

An abundance of gold leaf and rich colours enhance the jewel-like appearance of the altarpiece. It is easy to imagine how in its ornate gilded frame it presented a magical image, lit by candlelight in the family chapel. The use of such splendid material – real gold leaf to add highlights in the picture and to cover the frame, and semi-precious stones like lapis lazuli, which were ground up to make the rich blue that is so dominant in the picture – tells us a great deal.

Firstly, the patron must have been wealthy enough to afford these expensive materials – we know that paintings such as these were seen as symbols of wealth since in the contracts between artists and patrons there were often clauses stating how much gold and semi-precious pigments were to be used. In the case of the Strozzi family, who were wealthy Florentine merchants, we know they were keen patrons across several generations. (There is another *Strozzi Altarpiece* showing Christ enthroned with the Virgin and saints by Orcagna [Andrea di Cione] dated 1357, which remains in its original setting in Santa Maria Novella in Florence.)

Secondly, the decorative effect of Gentile's painting as a whole adds much to the luxurious feel of the picture. If you look at it quickly, the background, foreground, and all the figures seem to form a rich pattern across the picture rather like a woven fabric. The pattern-like quality of the picture surface, together with the opulent materials and the flatness of the image (there are no illusions of space or depth in this painting), are all characteristics of a mode of painting known as International Gothic. Here, as in most of art history, 'International' refers only to the West, and in this particular case to Europe since America was not really known about when this work was made. This view of the world begins to tell us something about how histories of art have been written, very much from a Western perspective, based on Western ideas and placing emphasis on the kinds of values that a male-dominated society and culture wants to read about and wants to see in the works themselves. One of the aims of this book is to show that we can think about the same objects in different ways to show their richness and value as historical documents or evidence.

My second painting is known as *Las Meninas* (Fig. 6), by Diego Velázquez (*c*.1658–60). Once again, we find a work of art with more than one name. It is really a portrait of the family of King Philip IV of Spain, and it was only in a catalogue of the royal collection of pictures written in 1843 by Pedro de Madrazo that the title *Las Meninas* (which means 'The Ladies in Waiting') was given to the work.

In this painting the artist has become more dominant than his subjects, as not only do we know this work to have been one of his masterpieces, but he has actually included himself in the picture. We see him standing behind the canvas to the left of the picture, looking out at us. We can only assume that his royal patrons were happy for Velázquez to include himself in this family portrait – he is certainly one of the dominant figures, the King and Queen being seen only as reflections in the mirrors at the centre of the back wall.

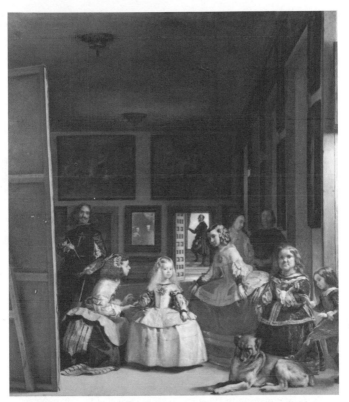

6. *Las Meninas* ('The Ladies in Waiting') by Diego Velázquez (*c.*1658–60). The artist included himself in the portrait of the family of King Philip IV of Spain.

The inclusion of such an obvious self-portrait shows the kind of status artists can come to hold, not just as court painters, as here, but more generally when they achieve an almost celebrity-like status. Their reputation can prefigure, or even overwhelm, their work. This continues to the present day, when we remember the names of artists more readily than the titles of their works – notable examples include Damien Hirst or Tracy Emin. But there is no doubt that Velázquez is seen as one of the major figures in the

history of Western art. He is particularly praised for his handling of paint; there is a looseness to the brushstrokes that is slightly impressionistic. Indeed, Edouard Manet, one of the founders of the Impressionist movement in France, went to Spain and was deeply influenced by the work of Velázquez.

Also look at the way light is handled: we feel as if light is flooding in from the windows to the right of the picture and spotlighting the little girl in the middle. See also how the open door in the background brings a different light source into the picture. *Las Meninas* also raises some important questions about pictorial space. We must always remember that the picture surface is flat – any sense of space or depth is an illusion. Some artists have little interest in trying to create the illusion of depth – or 'a window on the world' as some have called it. Another look at the Gentile reveals that there is little illusion of pictorial space, the figures are jumbled up flat against the picture surface. By contrast, Velázquez creates the illusion of a room using the standard device of linear perspective.

But there is much more to this painting. We assume what we are looking at is Velázquez's view of himself and his sitters in the mirror he was using to paint himself. This might explain why the light comes in from the right rather than the left, which is much more common in Western art – we are seeing a mirror image of the actual scene. But the King and Queen appear in the picture in the mirror at the centre of the back wall. So, who is Velázquez actually painting? We might think it is the little girl, as she is centre-stage and spotlighted, but the artist is looking beyond her, perhaps towards the figures we see only on the mirror. We, the viewers, are drawn into this complex set of spatial and compositional relationships as the artist looks out at us – as if he were painting our portrait and we look back, taking on the role of the King and Queen reflected in the mirror. This aspect of *Las Meninas* raises some important issues in art history.

In particular, there is the idea of art as illusion – what we are really looking at is brushstrokes on canvas; the rest is made up of our cognitive and intellectual processes that give the picture its meaning – in terms of recognizing it as a portrait and the ways in which it plays with our sense of perception. *The Adoration*, which is painted on panel, gives the illusion of fabrics and jewels in a flattened tableau that we stand outside; the artist's craft is hidden in the smooth picture surface and rich materials. Conversely, *Las Meninas*, painted on canvas, creates a complex illusion of three-dimensional space which both draws us in and repels us. We are very aware not only of the artist but also of how the paint has been applied to the canvas in the broad brushstrokes, creating a realistic effect.

I now want to move on to representations of the world and of ideas executed in different media, and I have chosen a classical sculpture and a recent installation work as a means of doing this.

The *Apollo Belvedere* (Fig. 7) is perhaps one of the best-known sculptures from the ancient world. This is due not least to its striking appearance – it is over 2 metres (7 feet) in height and made entirely of white marble. It is an image of the Greek god Apollo, who was one of the twelve gods of Olympus and who represented the classical Greek spirit, standing for the rational and civilized side of human nature.

Although there are many myths that narrate the episodes of Apollo's life, the title of this sculpture is taken from the place where the sculpture was displayed. It was placed in the Belvedere Courtyard (now part of the Pio-Clementine Museum) built for Pope Julius II in 1503, the first in the papal collection of ancient statues to be displayed there. This was a Roman copy of a Greek original from the 5th century BCE; the statue may have been sculpted by Leochares, one of whose works is mentioned in Pliny as being an Apollo wearing a diadem.

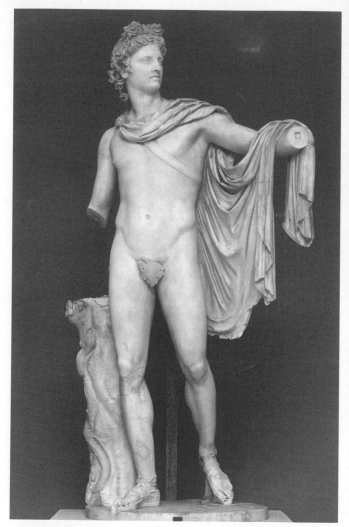

7. One of the best-known sculptures from the ancient world, the *Apollo Belvedere* is more than 2 metres (7 feet) high. It is a Roman copy of a 5th century BCE Greek original.

As the twin brother of Artemis, known also as Diana, Apollo was considered to represent masculine physical perfection, just as his sister represented female perfection. This sculpture certainly exploits the idea of physical perfection – the smooth finish of the marble adds to the illusion of soft flesh and muscle of the god's body and his blemishless idealized face. The contrast between the folds of the drapery and the smoothness of the flesh emphasize the texture of each and the sculptor's skill in making hard stone appear to be two quite different substances. Although this image of Apollo, like many others of men from antiquity, was meant to celebrate the physical perfection of the human body, here Apollo's modesty is presented by the addition of a fig leaf over his genitals. This is unlikely to have been there in the Greek original, but at some later date changing attitudes towards nudity and representations of the body and sexuality demanded a fig leaf be added, and it has remained in place.

It might appear strange that amidst all this idealized human perfection, there is a rather unattractive tree trunk. The texture of the bark adds little to the image, unlike the contrast between the cloak and Apollo's flesh. Closer examination reveals that the figure's right forearm and left hand are missing. And these begin to offer us clues as to why the tree trunk is there. Sculptures rely on the tensile strength of their material. Marble is not a very good material with which to carve outstretched limbs as it breaks quite easily, as we see here. Indeed, the cape not only works as a compositional device but also has a practical application, supporting Apollo's outstretched arm. Thinking about the sculpture in terms of balance and the qualities of the material, the tree is, then, another device to support the weight of the whole. We can see how vulnerable the sculpture is as the right forearm has gone. The tree trunk jars with the rest of the composition as it, like the fig leaf, was added later. This time we can be almost certain that the Roman copyist added it, as the Greek original would have been cast in bronze – a material with far greater tensile strength, which is necessary to achieve this kind of pose. One of the consequences of the use of marble rather than bronze is

23

that we mistakenly think of all classical sculpture as being white, so underscoring the idea of classical art as pure, simple, and as a result of enduring value.

The *Apollo Belvedere* now begins to tell us a great deal about a range of aspects of art history. Firstly, there is the question of the re-use and re-interpretation of classical forms across time. We are content to see Apollo as a fine example of Greek sculpture. Ancient Greece and Rome are often referred to as the classical world – this pinpoints a period in time. But the word 'classic' also means a pinnacle or exceptional example that conforms to a restrained and refined style and has enduring quality. The combination of the art from the classical epoch with this value judgement sets up the idea that 'classical' is best. And we can see how the interest in this style of art, in its broadest sense, has endured throughout time. The Romans copied or adapted much from Greek art and architecture. Indeed, most of our knowledge of Greek sculpture comes from Roman copies of Greek originals.

In the Renaissance, when interest in the classical world enjoyed a widespread revival, the *Apollo* was acquired by the Pope to form the beginnings of the papal sculpture collection. The interest in the artworks of antiquity was such that it was considered appropriate for Christian collections, including that owned by the Vatican, to contain images of pagan gods. The pose of Apollo, and indeed many other classical sculptures, has been copied and quoted by many artists, sculptors, painters, and engravers from subsequent generations, and this tells us how classical forms have been re-used and re-interpreted, or even rejected, at various times. The pose is an example of classical contrapposto, where one side of the body does the opposite of the other. Apollo's left side is open with his arm outstretched whilst his right is closed, similarly his weight rests on only one foot, which also gives a feeling of movement.

The *Apollo Belvedere* also tells us something about the rise in the interest in collecting and display of art – here it has even influenced

the name of the work – and how the amassing of objects gave prominence to certain types of works and made them available to artists to copy and learn from. The Vatican collections are important in this regard as artists visited Rome as part of their education from the 16th century onwards.

The further aspect of art history that the *Apollo Belvedere* introduces is iconography, an important method for understanding the meaning of art. This is discussed more fully in Chapter 5, but suffice to say here that it is the study of the subjects of stories depicted in art, whether it be religious or secular. We have already seen how this works with Gentile's *Adoration of the Magi* – the story behind the image. Iconography can also include the study of certain elements of a work of art that act as clues or symbols as to what is going on or who is being depicted. In the case of the *Apollo*, if we did not already know this was an image of the Graeco-Roman god, we might be led to that conclusion because the figure wears a crown of laurel leaves, which Apollo was given in recognition of his achievements in the arts.

My fourth example is an installation work by a woman artist who was at the forefront of the feminist movement. Judy Chicago's *The Dinner Party* (Fig. 8) was first exhibited in 1979. On the surface it seems a very laudable effort to bring famous women to the attention of the general public. And, significantly, we also have the artist talking about her work, so we know what she intended:

My idea for *The Dinner Party* grew out of research into women's history that I had begun at the end of the 1960s ... the prevailing attitude towards women's history can be best summed up by the following story. While an undergraduate at UCLA, I took a course titled the Intellectual History of Europe. The professor, a respected historian, promised that at the last class he would discuss women's contributions to Western thought. I waited eagerly all semester, and at the final meeting, the instructor strode in and announced:

'Women's contributions to European intellectual history: They made none.'

I was devastated by his judgement, and when later my studies demonstrated that my professor's assessment did not stand up to intellectual scrutiny, I became convinced that the idea that women had no history – and the companion belief that there had never been any great women artists – was simply a prejudice elevated to intellectual dogma. I suspected that many people accepted these notions primarily because they had never been exposed to a different perspective.

As I began to uncover what turned out to be a treasure trove of information about women's history, I became both empowered and inspired. My intense interest in sharing these discoveries through my art led me to wonder whether visual images might play a role in changing the prevailing views regarding women and women's history.

Judy Chicago, *The Dinner Party* (1996), pp. 3–4

Chicago's triangular dinner table had place settings made out of traditionally feminine 'crafts' such as embroidery and pottery, with the name of a famous woman, for instance Virginia Woolf and Doris Lessing, appearing at each place. This might seem a worthy effort but – look more closely – on each of the plates the fruit and flowers, which at first glance seem innocuous enough, form models of female genitalia. This allegorical reference to the female sex alluded to in fruit and flowers typifies feminization of art as these elements are considered decorative and domestic. Chicago's work had and still does have its critics. Some feminists see it as portraying biology as destiny. My purpose in including it here is that it raises some more important questions about art history. Most obviously, it shows how art can have a distinctly political purpose and be quite a provocative means of getting across ideas. Here, Chicago uses the technique of unsettling the viewer as we look at something that appears

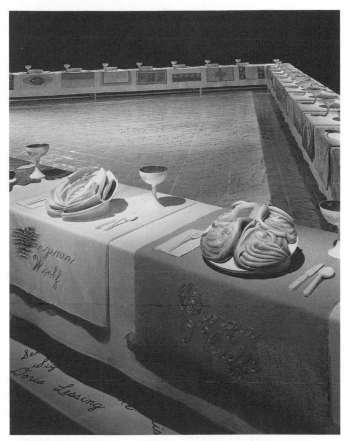

8. *The Dinner Party* by Judy Chicago was first exhibited in 1979 at the San Francisco Museum of Modern Art.

almost twee, but soon the familiar becomes disturbing. It also raises the issue of women in art and of other minority groups. It is quite easy for women, and for those from minority ethnic groups, to became subcategories of art history. This implies that the main topic is the white Western male as subject, artist, and historian. What follows in this volume challenges that view.

The Dinner Party also tells us about the ephemeral nature of artworks – it is an installation with no permanent home. That is a fragile enough existence, but as its message is now dated or unwelcome in the eyes of many, it remains packed away from view. And this raises the issue of fashion and taste, as well as the relationship between artists and artwork where there is no patron or gallery.

My four images have set up much of what follows in this book. All of them demonstrate in different ways that art history is not just about describing images that represent the world we think we see. The subject is far more complex and rich. It is a way of looking at the culture and society of different epochs and seeing how we think about these periods and how attitudes have changed across time. The huge range of subject matter enables us to use art history to think about these issues in relation to themes such as personal and public life, religious and secular art and practices, political activism and cultural domination. The following chapters explore these different aspects of art history. But in the final chapter I end where I began with the objects themselves, describing how in the light of the various aspects of the discipline covered in this introduction we can 'read' art history starting out from artworks.

Chapter 2
Writing art history

In recent years much scholarship has been concerned with the historiography, that is to say the study of the history or the histories, of art, rather than with the subject itself. This is an important concern that intersects at certain points with the issues raised in this chapter. Here, I want to emphasize the different narrative frames for art history to examine the various ways in which it can be written. These modes of writing emerged in the previous chapter, where emphases on the biography of individual artists or on style were shown to be both popular and enduring narrative frames for art history. Furthermore, I introduced the question of how we respond to visual objects using words. I now want to think about the ways in which art histories have been written in order to describe art and to give it a context. Following on from this, I discuss various ways of thinking about art history in Chapter 4, and there are points of contact between that chapter and this.

There are three main strands that I want to address here. Firstly, I take examples of writing about art from a broad time span to see what, if anything, the writers have in common and also to consider the differences between them. Secondly, I look at how gender and gender bias have influenced the development of art history. Thirdly, it is important to think about our expectations of progress and evolution in art in relation to how histories are written. In this way,

we can see how the various ways of writing about art can change the way in which we see the object and think about its history.

Art historians through the ages

Gaius Plinius Secundus, known as Pliny the Elder (CE 23/24–79), was a Roman writer whose 37-volume *Natural History*, dedicated to the Emperor Titus, is one of the best-known works on art and architecture from the ancient world. The huge work is largely concerned with natural history, as the title suggests, of the Graeco-Roman world, but art is also covered. In the Renaissance period in Italy a great deal of attention was paid to textual sources about the art of antiquity. There was a wide range of texts available, but some survived only in fragments or were only available in Greek. By contrast, Pliny's encyclopaedic volumes had survived intact and were translated into Italian in 1476, making them far more easily accessible. As a result, the attention paid to Pliny's discussion of art took on a disproportionate significance to the aims of the work as a whole. Nevertheless, the *Natural History* was an important influence on the development of writings on art as well as on art itself. And Pliny's description of art objects helped in the identification of antique sculptures that were discovered during the Renaissance, as well as later periods. It is hard for us to imagine what it must be like not to recognize the subject of sculptures such as the *Apollo Belvedere* (Fig. 7). But from the Renaissance to the 18th century only careful coordination between written descriptions and surviving sculptures made identification possible. How engaging and enigmatic these anonymous fragments of the past must have seemed, not unlike the prehistoric art that we speculate about today.

Pliny also paid attention to the biographical details of the lives of artists. Most famously, his account of the painter Apelles was very influential for the formation of artistic values in the Renaissance period. The emergence of the artist as someone with status and an intellectual approach to their craft was an important part of the Renaissance period in art. This also helped ensure the continuance

of the classical tradition, as artistic status was enhanced by knowledge of the art of ancient Greece and Rome.

Pliny was an important influence on one of the most enduring and influential writers about art, Giorgio Vasari (1511–74). He was a Florentine painter and architect who is often seen as the first historian of art and his work the *Lives of the Artists* is still in print today and is an important source book for our knowledge about Renaissance artists. Vasari was aware of the precedents for this kind of enterprise, including Pliny's *Natural History*, as he states:

> I left out many things from Pliny and other authors which I could have used had I not wanted, perhaps in a controversial way, to leave everyone free to discover other people's ideas for himself in the original sources.

But his biographies proved equal to their antique sources, as Vasari's *Lives* was first translated into English in 1685, so becoming a model for how to write about art in the post-classical world.

Vasari's *Lives*, as they are often known, comprise three parts. The first of these covers artists Cimabue and Giotto, who were working in what Vasari sees as the 'rebirth' of the arts after the Dark Ages. The second part discusses the period we now call the Early Renaissance and includes the artists Masaccio and Botticelli, the architect Brunelleschi, and the art theorist and architect Alberti. It is important to remember that there was little differentiation between the practices of architecture, painting, and sculpture at this time and many 'artists' practised all three. (Vasari, for instance, designed the building that is now the Uffizi Gallery in Florence.) The final part of the *Lives* begins with Leonardo da Vinci and covers what we now regard as High Renaissance artists.

Vasari's choices about how to arrange his material have had a resounding effect on art history. By placing so much emphasis on the 'genius' and achievements of an individual artist, Vasari laid the

foundations for the kind of connoisseurial approach to art history I discussed in Chapter 1. Vasari was one of the first historians to make qualitative judgements about art in order to create a canon of great artists and within this great works by these practitioners. For Vasari, quality was based on the artist's skill in the illusion of naturalism and the technical ability required for this degree of idealized 'beauty'. Moreover, as I have already pointed out, this kind of approach to art history encourages the attribution of works of art to an artist, or the influence of one artist on another, on the basis of stylistic similarities – if two things look alike, they must be related.

Firstly, it's important to consider the idea of writing a history based solely on the lives of artists and whether this is really a history of artists rather than art history. There is the obvious problem that Vasari probably knew a lot more about some artists than others. And, like all of us, he had his personal favourites. In the case of the *Lives* this had a resounding effect on how it was written and how it has influenced art history. Vasari's first edition of the *Lives*, published in 1550, was intended to be a celebration of the genius of Michelangelo Buonarroti – the temperamental sculptor and painter who had stunned early 16th-century Italy with his painted decoration of the Sistine Chapel ceiling (1508–12) and his giant marble sculpture of David (1501–4). Indeed, Michelangelo is the only living artist whose biography appears in the first edition of the *Lives*. Michelangelo died in 1564 and the second, much better known edition of the *Lives* appeared in 1568.

The problem with Vasari's trajectory of art history is the simple question of what happened to art after Michelangelo. Did it stop or go into decline? Once the pinnacle of perfection had been reached, where could art go? You can see from this that setting up the idea of artistic progress, whether it be towards the superlative art of one individual, as here, or a more abstract idea of the re-creation of classical forms or the flawless representation of the human subject, implies that there is an end to art history. This point raises an important issue about ways of writing any kind of history. Histories

are written with the benefit of hindsight; we know what came before and after the events being discussed. The idea that events unfold towards an identified outcome is known as teleology. But history continues beyond the moment at which the historian is writing; we are, then, capable of reconfiguring the processes and narratives of art history. But I am getting ahead of myself here.

The second point about Vasari is that the way he divided up the development of art in Italy from c.1270 to 1570 has never really been challenged. We still see the artists he places in Part Two of the *Lives* as belonging to the Early Renaissance, showing only the beginning of what Vasari saw as the important aspects of art – that is the re-use and re-interpretation of the art of antiquity. But we know that Vasari's contemporaries did not see such divisions between Early and High Renaissance artists. Moreover, Vasari had neither interest in nor appreciation of the art of earlier periods which are now known as Gothic or Byzantine. But there is overlap as well as disagreement between Vasari's division of art history into specific periods and those set up by later historians. For instance, Giotto is included in the *Lives* as the *prima luce* ('first light') of the Renaissance as in his work Vasari saw the first signs of an interest in nature, whereas more recently Giotto has been presented as working in the Gothic tradition because of his interest in the stylized poses and compositional formulae of that period.

Although Vasari did not see any relationship between art, society, and politics, he did set up criteria that could be used to judge the quality of a work of art. These five aspects of art have done much to underpin the way in which the story of art has been put together by subsequent generations. A brief discussion of these also enables me to outline one of the major influences on the philosophy of art, Neoplatonism, and how it interacted with artistic practice in the Renaissance period. Vasari's criteria include *Disegno* – the art of good draughtsmanship or design. Here, Vasari is using the Neoplatonic idea that the artist has the *Idea* of the object he is trying to reproduce planted in his mind by God. The artwork,

whether painting or sculpture, relates both to the object the artist sees and the perfect form that exists only in the mind. The second criterion is *Natura* – art as an imitation of nature was a new concept in the 15th century. Here again, Vasari brings in the Platonic idea of the artists being able to improve on nature through the knowledge of perfect forms. Thirdly, *Grazia*, or grace, is an essential quality of art as evident in the softness of the works of artists like Michelangelo. Fourthly, *Decoro* refers to artistic decorum or appropriateness – for instance, a saint should look like a holy man or woman. This also came to mean a form of modesty that demanded that the genitals of sculpted or painted nudes were covered up – sometimes after the work was finished. Vasari's final category was *Maniera*, which refers either to an artist's personal style or to that of a specific school of artists. These criteria still have a great deal of currency today as part of the continuing interest in the naturalism of classical art as refracted through the Renaissance and beyond.

Vasari's method of writing about art history remained focused on the works themselves and relied on close observation of detail together with biographical fragments from the artist's life. I think it is useful here to compare Vasari's discussion of a given work with that of a different art historian. Ernst Gombrich is one of the best-known cultural historians from the 20th century. His work centred mainly on the Renaissance, and he wanted to examine works of 'high' culture (or art) as evidence of the broader intellectual climate of the time. Gombrich was also interested in anthropology and psychoanalysis as ways of getting to the cultural meaning of art. As a scholar of the Renaissance, Gombrich has been accused of conservatism and reinforcing canonical art history. But his work also covers the psychology of art, using cartoons and advertisements as his evidence. Whether he is discussing high art or popular culture, Gombrich's awareness of the changing functions of images and the importance of their social and cultural context imbues his analysis with a layering of meaning and nuances, so that I find it

hard to see him as a traditionalist. That said, I must here raise my hand and state my objections to Gombrich's best-selling book *The Story of Art*, first published in 1950 and still in print today. This sets up a linear development of art, focusing on canonical artists with little regard to the broader contexts or theoretical approaches manifest in his other writings. Like Vasari's *Lives*, *The Story of Art* is all about 'great *men*' and 'style'. If not by now, then certainly by the end of this book, you will see all the reasons behind my negative position on the 'caveman to Picasso' linear, teleological narrative of art.

A comparison between how Gombrich and Vasari write about the same work of art demonstrates the differences in their approaches to art history. Raphael's *School of Athens* (Fig. 9) is a useful example for this exercise as it is a complex image with enduring appeal. Raphael, alongside other artists, was employed by Pope Julius II to decorate a series of rooms in the Vatican palace – these are often referred to as the Vatican *Stanze*. The wall paintings, known as frescoes, in the Stanza della Segnatura, the Stanza dell' Incendio, and the Sala di Constantino were worked on by Raphael and his workshop assistants from about 1509 onwards. The Stanza della Segnatura is usually considered to be the most important of these rooms as Raphael was most involved with the execution of the work there. The two main frescoes in this room were the *School of Athens* and the *Disputa* concerning the Blessed Sacrament – their subject matter showing an interesting juxtaposition between the secular and the sacred, or the pagan and Christian. Pope Julius II was a very keen patron of the arts – his sculpture collection at the Vatican, which included the *Apollo Belvedere*, was discussed in the previous chapter.

Vasari's account of these important commissions is as follows:

> At that time Bramante of Urbino, who was working for Julius II [told Raphael] that he had persuaded the Pope to build some new apartments where Raphael would have the chance to show what he could do.

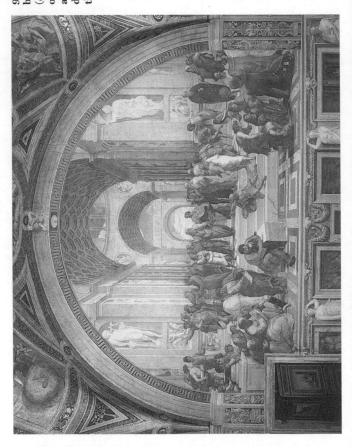

9. *School of Athens* by Raphael (c.1509–11/12), one of the frescoes adorning the Stanza della Segnatura in the Vatican, Rome.

[A]fter he had been welcomed very affectionately by Pope Julius, Raphael started to paint in the Stanza della Segnatura a fresco showing the theologians reconciling Philosophy and Astrology with Theology, in which there are portraits of all the sages of the world shown disputing among themselves in various ways. Standing apart are some astrologers who have drawn various kinds of figures and characters relating to geomancy and astrology on some little tablets which, by the hands of some very beautiful angels, they are sending to the evangelists to expound. Among them is Diogenes with his cup, lying deep in thought on the steps: this is a finely conceived figure which deserves high praise for its beauty and the appropriate negligence of its clothing. There, also, are Aristotle and Plato, one holding the Timaeus, the other with the Ethics; and round them in a circle is a great school of philosophers. The astrologers and geometers are using compasses to draw innumerable figures and characters on their tablets; and it is hardly possible to describe how splendid they look.

In his 1972 book, *Symbolic Images*, Ernst Gombrich challenges and corrects Vasari's account:

On his arrival in Rome ... Raphael 'began in the Camera [Stanza] della Segnatura a painting of how theologians harmonize Philosophy and Astrology with Theology, where all the sages of the world are shown discussing in various ways.' These opening words of Vasari's account ... naturally set the key for the interpretation of these frescoes for centuries to come. Not only did Vasari establish the conviction that the subject of this cycle was meant to be of profound philosophical import, he also enforced the interpretation by isolating the individual frescoes from their intellectual and decorative context We now know the source of this error: Vasari worked from engravings after the frescoes [and as a result] placed Evangelists among the Greek philosophers ... [and] this tendency persisted ... and though scholars failed to agree on any one interpretation the conviction persisted that there was a key to these frescoes which must be in accord with the humanistic ideas of the sixteenth century.

Gombrich blames the misunderstandings of the iconography of the *Stanza* as a whole on Vasari's misleading account and the way in which subsequent historians looked at the individual components of the room – the ceiling and walls – instead of the composition as a whole. He argues that, if read in this way, the room, with its mixture of pagan and Christian subjects, 'should not have caused any surprise to anyone who knew the habits of medieval moralists or indeed of St Augustine.' The ceiling comprises enthroned personifications that relate to the representations underneath; these in turn amplify these ideas. *The School of Athens* is coupled with *Philosophy*, which together with the other ceiling figures of *Law*, *Theology* and *Poetry* represented the Liberal Arts as taught in Italian universities at that time.

Vasari's approach to art history, as we have seen, still has currency, but challenges to it – or more accurately a different way of thinking about the subject – came about in the 18th century. Johann Joachim Winckelmann was one of the first historians to put art in its context using as many different sources as possible. Placing art in its cultural context was a revolutionary idea as it meant that the art became more important than the artist. Indeed, Winckelmann stated that individual artists had little to do with his project, which was to come up with a more systematic way of organizing knowledge about art. That said, Winckelmann still emphasized that a detailed examination of the work of art was necessary, and like Vasari he adhered to the connoisseurial preoccupation with identifying ideal beauty or perfection. But where Vasari got into difficulties over the problem of the 'decline of art' after the death of Michelangelo, Winckelmann confined his interests to the art of antiquity. For Winckelmann, ancient Greek art from the 5th century BCE, known as the classical period, constituted the pinnacle of artistic achievement in terms of the representation of beauty and perfection. The biographical details of the artists who produced these works are very scant, but this was of little concern to

Winckelmann who saw art history as being about the aesthetic rather than the artist. Winckelmann introduced a systematic, chronological study of art history. The artistic remains of antiquity were seen as coherent survivors of the classical age that could at once determine and augment the human condition (although unbeknown to Winckelmann many sculptures were Roman copies of Greek originals). The 'invention' of ancient Greece, or at least its establishment as a high point in human civilization, was an essential element of this Eurocentric concept of an ideal or classical tradition. In turn this had relevance for modern times. In his *Imitation of the Painting and Sculpture of the Greeks* (1755), Winckelmann states:

> [there] is but one way for the moderns to become great, and perhaps unequalled, . . . by imitating the ancients It is not only nature which the votaries of the Greeks find in their works, but still more, something superior to nature; ideal beauties, brain born images.

Winckelmann's ideas draw heavily on mid-18th-century theories of language, which was seen as having developed its resources to allow a clear knowledge of things, but excesses in style and rhetoric led to its degeneration. He traced a similar path through art, seeing classical Greek art as the pinnacle and the subsequent movement and vigour of the Hellenistic period as the 'excess' and 'degeneration'. This idea of development and decline in the art of the ancient world has remained the standard chronology for art history. Winckelmann's analysis, or system of history as he preferred to call it, is firmly rooted in the verbal tradition – the critical apparatus of language was transposed onto art. Winckelmann relied on textual descriptions of objects to identify works in order to write his verbal history. It is important to remember here that neither Winckelmann nor Vasari had access to good, accurate illustrations of the works they were discussing – something we take for granted today. They had to rely on prints and

engravings of varying quality that could be misleading. This point is implicit in Gombrich's critique of Vasari's analysis of *School of Athens*. But the absence of good visual records has much wider importance, as it was not until the middle decades of the 20th century that photographic techniques became sufficiently refined to enable the close study of art objects other than *in situ*. Clearly, the use of photography brings with it a new set of problems, but it does make us think carefully about the relationship between verbal and visual systems of recording art, a point that is developed further in Chapter 5.

The idea of cultural history as developed by Winckelmann had as much resonance in the writing of art history as Vasari's biographical approach. For instance, the Swiss historian Jacob Burckhardt adopted a similar approach to Winckelmann in his two-volume *The Civilisation of Renaissance Italy*, which first appeared in German in 1860, but was quickly translated into English. Burckhardt placed the art of the Italian Renaissance firmly in its cultural context to explain its 'civilizing' and 'civic' qualities. *The Civilisation of Renaissance Italy* remains a standard work and did much to prompt a revival of interest in this period as well as endorsing the predominant position given to the survival of the classical tradition in Western art.

Winckelmann also had influence in the way in which the art object attained an autonomous status. His emphasis on the work rather than the artist may well have helped open up a new way of thinking about art history. In 19th-century Germany one of the most influential philosophers in the history of Western thought, G. W. F. Hegel, proposed that the shape of history was not one of linear progression of inevitable decline and fall – which had been one of the problems that faced Vasari and Winckelmann. Instead, he believed that history was the result of the workings of a 'world spirit' and that art was one of the ways in which this spirit manifested itself. The term *Zeitgeist* ('the spirit of the age'), now familiar in English, comes from Hegel's philosophy of history. His

system is a way of explaining not just works of art but all cultural production from a given moment in time. As such the actions of individuals, that is to say artists in our case, have little importance, and nor did the social context of the production of a work of art matter – something I pick up on in Chapter 4. The preoccupation with style from an Hegelian perspective is different from Vasari's connoisseurial approach. Here, style has a kind of autonomy as it develops over time and transcends human activity, so playing down the idea of genius so crucial to other ways of writing art history. Ernst Gombrich's idea of cultural history was influenced by Hegel, but Gombrich attributed art or images with changing functions that react with their context – something Gombrich called an 'ecology of art'. This is a term borrowed from sociology that means the relationship between art and its environments.

It is really only in the 20th century that we see any break with these two principal preoccupations with author (artist) and form (style). We have seen how the art of antiquity dominated artistic thinking and practice, and how the very term 'classic' came to denote both an historical period and a favourable value-judgement on the production of that time. Later art historians were almost apologetic, convinced that the art of their own time did not match up to that of the ancients. The work of Gombrich and his contemporaries, such as Rudolf Wittkower and Fritz Saxl, is a rich melange of philosophy, history, and theology that gives us a *Kulturgeschichte*, or a cultural history of art – but this is primarily concerned with the art of the Renaissance and its derivatives.

New ways of writing about art did emerge in the 20th century, when historians focused far more on the art of their own time, rather than concentrating on its relationship, favourable or otherwise, to that from the past. So far in this book I have talked mainly about art as being a representation of the world we think we see. And this chapter has shown us that art history developed partly out of a

concern to order art according to its competence as a means of representation, whether realistic, naturalistic, or idealized. At the beginning of the 20th century a tradition of non-figurative art emerged – that is to say, art that does not portray the world as we think we see it.

Judy Chicago's installation is a useful stepping stone into this kind of art, which some find off-putting or unappealing – 'but is it art?' is a frequently asked question. When we looked carefully at *The Dinner Party* (Fig. 8) in the previous chapter, I was discussing the idea of biography – not just of the artist but also women's lives represented through place settings and text – and I spent some time explaining the concept behind the work. My point here is to show that *The Dinner Party* is about an idea – a sociopolitical statement about women. In this way it is quite different from the other works I discuss in Chapter 1. Chicago's installation comes out of the shift in attitude in the 20th century to what art can do and how it can do it. It was no longer bound by the forces of the Hegelian spirit or the cyclical peaks of Vasari's classical age, which came to prominence again in the Renaissance. The emergence of Modernism at the beginning of the 20th century made art historians think for the first time about a movement that was not the result of years of evolution and repetitive tradition. Instead, Modernism burst onto the scene and presented a completely different set of values and aesthetics that demanded new responses.

From the end of the Second World War up until the late 1960s, Clement Greenberg was one of the foremost critics of modern art. Greenberg dispensed with the need to consider the social determinants of art – both its production and interpretation (of history). The Avant-Garde – what we might now call the Modern Movement – was the focus of Greenberg's enquiries. This had emerged in France in the mid-19th century as part of an increasingly autonomous tradition in the production and interpretation of art, and this carried through into the 20th century

with the work of abstract artists such as Pablo Picasso, Piet Mondrian, and Joan Miró. Greenberg believed that this kind of 'avant-garde' art was necessary to keep culture alive. His firmly held socialist beliefs underpinned his ideas that a new culture was needed that would replace that of the past.

Later, Greenberg's position developed into the view that visual art must concern itself only with what is given in visual expression and not, therefore, make any reference to any other kinds of experience. His insistence on the autonomy of art was understood as a shift in his thinking towards a political point of view that supported rather than challenged the *status quo*. Instead of calling for a fundamental shift in art practice and appreciation, Greenberg now worked to exclude from the privileged domain of high art – the canon by another name – the work of women artists, minority groups, and elements of popular culture. Partly through Greenberg's efforts, Modernism became a bastion of male conservative values produced by and for white men to the exclusion of other groups.

According to Greenberg, the essence of art lay in its purity and self-definition and the necessity for it to be true to its medium (as opposed to being expressed through other means, such as the verbal). As such, Modernism must exclude any element of representation and instead provide an abstract optical experience. This is evident, for instance, in Picasso's 1913 Cubist collage *Guitar* (Fig. 10). We can make out fragments or suggestions of a guitar, but the image is really a set of abstract forms and shapes with different materials to give variations in texture. These abstractions provide a set of references to the scene Picasso may have been looking at – including the guitar, the wallpaper, which we see has a heavy pattern, and a newspaper. Greenberg does offer a way of viewing this piece of abstract art, but it is only one way of thinking about Cubist collage – we might also want to consider the way space is flattened and reconfigured in an attempt to show more than one view of the object. This is not quite the way Greenberg would want

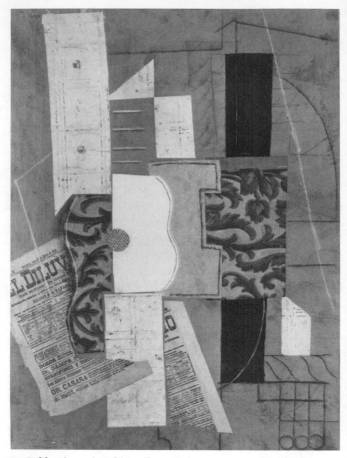

10. Pablo Picasso's Cubist collage, *Guitar*, was created in 1913.

to write about art, as the 'abstraction' is related back to the subject matter of Picasso's work. The Greenbergian model of writing about art history and art practice stood in complete opposition to what Chicago was trying to do in *The Dinner Party*. Chicago's handmade installation using 'feminine crafts and techniques' directly confronted the boundaries of art as defined by Modernism.

Gendered art histories

I now want to consider the bias in writing art history towards a male interpretation of the subject – even though many patrons and subjects were/are female. Complementary to this is the impact of the writing of women art historians such as Griselda Pollock and Linda Nochlin. It is now over a generation ago that the first feminist writings began to appear, mapping out a different way of seeing and understanding cultural production and the social relationships expressed therein. Griselda Pollock and Rozsika Parker identify the crucial paradox about attitudes to women in the writing of histories, specifically here those concerned with creativity:

> Women are represented negatively, as lacking in creativity, with nothing significant to contribute, and as having no influence on the course of art. Paradoxically, to negate them women have to be acknowledged; they are mentioned in order to be categorised, set apart and marginalised. [This is] one of the major elements in the construction of the hegemony of men in cultural practices in art.
>
> Griselda Pollock and Rozsika Parker, *Old Mistresses* (1981)

Alongside Pollock and Parker, Linda Nochlin has made a significant contribution to our understanding of this issue and her essay 'Why Have There Been No Great Women Artists?' remains a standard text on the question even though it was written in 1971. It is worth remembering that Nochlin was writing at the time that the women's liberation movement was at its peak – around the same time as Judy Chicago produced *The Dinner Party*. Nochlin's essay relies on a set of assumptions about what 'great art' is and the historical and gendered assumptions behind the idea of the artist. Nochlin argues that art is not an autonomous activity of a 'super-endowed' individual. Instead, 'art-making' occurs in a social situation and is an integral element of that social structure mediated by things like art academies, systems of patronage, and the artist as 'he-man' or outcast. In other words, society creates its own myths around the

idea of art and the artist that endorse the *status quo* within that society. Art history, up until the interventions by feminists, was part of that myth, or what we might call discourse. By asking different questions about the conditions for production of art we may well come up with a new set of ideas about the nature of art, artistic practice, and 'great artists'.

Although principally concerned with women, feminist art history has brought attention to issues of difference whether it be sexual, social, or cultural. And as a result we now look at and write about artworks and their modes of representation from different historical and aesthetic perspectives. There is no doubt about the tendency to accept whatever is seen as natural, whether in regard to academic enquiry or our social systems. But feminist art history made us think, for the first time, about the canon of art history and provided the means for us to think about artworks in different ways. I pick up this issue again in Chapter 4.

In recent years a number of studies have broadened the question of the control of visual material to include not only the relationship between men and women but also the relationship of homosexuality to art, sometimes called 'queer theory', and the relationship between colonizer and colonized in a post-colonial world. This opening up or questioning of the different power relationships existing between art and its users and producers is an essential part of the discipline.

The place of non-Western art in history

The 1960s and 1970s were certainly the decades during which the way we write about art was re-evaluated. We have already seen how Linda Nochlin and Clement Greenberg presented completely different views on this subject. And it is clear that writing art history is as much a process of exclusion as inclusion, and these choices are usually formulated on the canon of Western art. I want to stay with the idea of exclusion and think about how, alongside women,

artists and art from other cultures or groups have been omitted from art history. How can their work be placed within the field of enquiry?

But perhaps I am asking the wrong question. For instance, both African and Chinese art have histories that go back around 5,000 years – far longer than the art of the West. Western narratives usually begin with the ancient Greek world so, although reference is sometimes made to ancient Egypt and earlier periods, the main focus is on the last 2,500 years. But do we think of the art of China or of Africa as having a history in the same way as Western art? I am afraid not, as centuries of misconceptions about the sophisticated nature of African art show – African art is often described as 'primitive' or 'naïve', especially in relation to canonical art. We tend to forget that Egypt is part of the African continent, as the art of ancient Egypt is usually discussed in isolation. Sub-Saharan Africa has strong indigenous traditions that continue to the present day – the carved female figure from the Ivory Coast dates from the 19th century (Fig. 11). And it is important not only to acknowledge the appeal of African art, but also to restore it to its original social and historical context. This helps us understand more about the ways in which this art was produced, used, and received. In other words, we need to write (and think) about it in quite a different way.

The art of China includes an enormous variety of images, objects, and materials – jade objects (Fig. 12), painted silk handscrolls and fans, ink and lacquer painting, porcelain, sculptures, and calligraphy. Here again, our Western prejudices are brought to bear on surveys and histories of Chinese art. We tend to give prominence to sculpture at the expense of other art forms. And it is hard not to be impressed by the vast 'terracotta army' with its 7,000 or so life-size figures, recently unearthed. Equally, the delicacy of a piece of carved jade, in terms of the artist's skill and the quality of the material, can capture our attention. But it is important to take into account traditional Chinese definitions of what art is. Perhaps

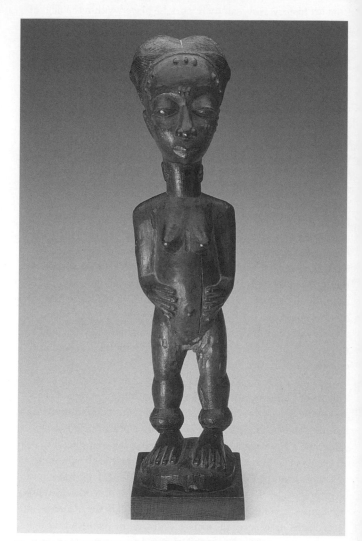

11. A Baule female figure from the Ivory Coast. This is a 19th-century artwork.

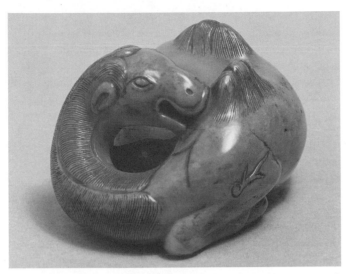

12. **The Chinese camel in yellow-green jade dates from the Tang or early Sung dynasty (8th to 10th century CE).**

appropriately for a chapter on writing about art history, the Chinese consider calligraphy as one of the most important art forms.

As in Western cultures, art in China had a variety of functions in society to do with death, court life, and religion, as well as being a signifier of wealth and pre-eminence and a tradable commodity. The essential thing to remember here is that the values that we may place on a certain object may be different from those applied by the society that produced it. The same is true for the hierarchy of importance we might accord certain media over others.

This leads me on to my third area of consideration in this chapter. I want to think about the canon and its influence on writing art history. The idea of the canon has already been mentioned in our consideration of feminist and non-Western art history, particularly in terms of the prejudices and preferences we are inclined to bring to these art forms. My focus here is on how we write about what is

described as primitive or naïve art. There are two main ways to look at and write about 'primitive' art. The first is Primitivism as a style of art that refers to the re-use and re-interpretation of non-Western forms by Western artists. We can trace the historical evolution of the notion of 'primitive' and the associated Primitivist phenomena from their first appearance in Western art as early as the 18th century right up to the present day. The second is 'primitive' as a value judgement applied to non-Western art, which can be seen as pejorative. In response to this, we can try to establish a theoretical definition of primitive art, conceived as an autonomous manifestation of art not linked to Western cultural constructs. I am interested here in the contradictions implicit in the imposition of our values onto non-Western art when these art forms have longer-standing traditions. In fact, the art of China or Africa shows us that there are histories of art that exist independently of the Western canon.

Western views on the primitive have come from both artists and historians. Perhaps most famous amongst these are Matisse, Picasso, and Roger Fry, who did much to promote Primitivism as an artistic style in the early part of the 20th century. The encounter between Western artists and writers and what has historically been called primitive art – the traditional, indigenous arts of Africa, Oceania, and North America – began with the 'discovery' of that art by European artists and writers early in the 20th century. These art forms were a vital catalyst that made artists rethink their relationship to the world. We can compare it to the discovery of perspective in the Renaissance, when artists developed the technical ability to accurately represent space. It is hard to overestimate the profound effect of primitive art. But we must remember that there was an intrinsic interest in primitivizing representations in modern art itself, as artists sought to break with the academic, canonical norms of artistic practice. There are many reasons why works by non-Western artists attracted modern painters and sculptors. And it is important to identify the different strands within Primitivism. First there is the romanticism of Paul

Gauguin, whose images of life on Tahiti present a vision of an idyllic non-industrial society. There is also what might be termed emotional primitivism, exemplified by the *Brücke* and *Blaue Reiter* groups in Germany, in which abstract forms are used to express mood. By contrast, the primitivism of Picasso and Modigliani draws on direct quotations from non-Western art. In his *Les Demoiselles d'Avignon* (1907), which is often seen as the beginning of modern art, Picasso paints the faces of the *demoiselles* as African masks. Finally, there is the idea of the primitivism of the subconscious that we see in Surrealism. Here, basic human impulses are associated with the notion of our primitive selves, reinforcing my point about the pejorative connotations of the term.

Primitivism is, then, a notion crucial to 20th-century art and modern thinking rather than a specific movement or group of artists. But is Primitivism one more example of Western colonial appropriation – or is there evidence of cross-cultural influence? It is true that the encounter between the West and primitive art took place at the height of Western colonialism. As a result, we must be aware that a number of racial and political questions come into play, either overtly or implicitly, in writings about both the art and the people who produced it. Recently, the notion of primitivism in the arts has troubled art historians, who have begun to question the formal, anthropological, political, and historical issues that have influenced the study of the arts of Oceania, Africa, and North and South America. But this does not necessarily result in a group of societies stripped of meaning; instead the interactions between these cultures and Western traditions have created entirely new identities.

Until recently, the tendency in the West has been to view the art of Oceania as primitive. But it is important to consider the meaning and significance of art for the people of the Pacific. These art forms are part of the social rituals and cultural practices of these peoples, for instance the ancestral carvings of Maori and Sepik ceremonial houses, or body art in Polynesia; and women's art forms, such as

bark cloth. And here we see the close connection between art history and anthropology – indeed some anthropologists see the word 'art' as too much of a Western term.

If we move out of the European arena to countries such as Australia to which large numbers of Europeans migrated, resulting in the dislocation of native peoples, we see that indigenous art traditions have been used to assert the presence of native peoples and their prior claim to the land. The interaction between First Australians and European Australians includes art forms from bark art to photography, rock art to sculpture, all of which show the rich texture of Australian art traditions.

Let's now turn the question of cross-cultural influence on its head and think about the impact of migration and diaspora where non-Western traditions have been brought to Western societies. Here I am thinking about slavery and African-American art. African-American art has made an increasingly vital contribution to the art of the United States from the time of its origins in early 18th-century slave communities. It includes folk and decorative arts, such as ceramics, furniture, and quilts, alongside fine art – sculptures, paintings, and photography – produced by African-Americans, both enslaved and free, throughout the 19th century. African-American art shows that in its cultural diversity and synthesis of cultures it mirrors American society as a whole. We need to think about the influence of galleries and museums, and of the New Negro Movement of the 1920s, the Era of Civil Rights and Black Nationalism in the 1960s and 1970s, and the emergence of new black artists and theorists in the latter part of the 20th century.

We need to look closely at the canonical works of those who built the empire and see how colonial subjects have been treated, whether they be slaves, descendants of slaves, or those whose lands were taken. Like women, these groups had largely been dismissed in the writing of art history as having no influence on or importance in 'mainstream' European art. This endorsed the idea that high art

was the presence of artists practising in the Western tradition with its accompanying notion of genius. As we have seen, this comprises an orthodoxy of material, subject matter, and approach – and of course it requires a white male artist. Non-Western art has largely been judged by a Western yardstick – it is 'primitive' but becomes Primitivism when adopted and adapted by Western artists.

But in recent years there has been a shift in attitude and an awareness of the colonial frame placed on non-Western art. This is evident in the way non-Western art is now being written about as having its own history – although this history is written by Westerners. Africans and First Australians, for instance, see their modern art as having evolved out of their own traditions and being 'given ' to them by Westerners. Indeed, is it not possible that Western art, whether modern or not, possesses its own ethnic peculiarities? This is the case not just in form but also in subject matter. Right at the beginning of this book we looked at Gentile da Fabriano's *Adoration* (Fig. 5) as an example of Christian art. This is a benign image, but many Christian images are of the violent deaths or martyrdoms of saints, or indeed Christ's own crucifixion. To those who stand outside the Western Christian culture, these images can appear really quite shocking. Inevitably writing about art will always be influenced by the cultural circumstances of the historian, as well as the producer and viewer of the work. It is also important to think about the politics and aesthetics of the major museum exhibitions that gained acceptance for art that had been both ridiculed and marginalized – an issue I discuss in the next chapter.

Chapter 3
Presenting art history

What do we expect when we enter an art gallery or museum? I think most of us are looking for history as well as art. It is quite usual to be confronted by a linear chronological sequence of artefacts, starting usually with Egyptian and/or Graeco-Roman times and working its way through to the present day. This varies, of course, on the specialization of the museum. But it is fair to say that chronology is one of the principal tools in organizing the display of works of art, and as we have already seen it is also one of the principal methods of writing art history.

For most of us, our first encounter with art is in a gallery or museum. Quite often these are large institutions belonging to the nation or the city where they are located. Their presence adds a certain cachet of cultural respectability to their location. The National Gallery in London or the British Museum are publicly owned and funded institutions. Other well-known national galleries are the result of a donation by private owners, which has since been augmented with public money. For instance, the Tate Gallery began as the sugar magnate Sir Henry Tate's personal art collection which he donated to the nation. Since then Tate, as it is now known, has grown into a series of galleries – two in London, Tate Britain and Tate Modern, and other venues in Liverpool and St Ives – all of which has been made possible by the use of public funds for the public good.

National collections and the museums in which they are housed are important focal points in the urban landscape. The Rijksmuseum in Amsterdam, The Prado in Madrid, or the Louvre in Paris hold some of the finest works of art in the world and all are impressive buildings. The displays in these European institutions centre on national schools of painting, but also reflect past trends in the history of collecting and so include works from antiquity, the Renaissance, and more latterly non-Western art from Asia, Africa, and Oceania.

The holdings in galleries and museums in the United States show how important the history of collecting remains. As the USA is a relatively new country, the excellent material in many museums is as much the result of private donations as of art bought on the European market as part of an active acquisitions policy. Benefactors who have bequeathed their personal collections to the nation are often remembered through the naming of a wing or rooms in the institution in their honour. Some of the museums and galleries in the United States that might be seen as the 'establishment' are really quite new. The civilizing appeal of these institutions is apparent in the story behind the founding of the National Gallery in Washington. This opened in 1937, more than a century after Washington had been established as the capital of the United States. It was funded by a private individual, Andrew Mellon, who was Treasury Secretary under President Hoover. Mellon saw the absence of a national gallery as a cause for discomfiture – not least when being obliged to tell foreign dignitaries that no such thing existed. Whilst Andrew Mellon maintained an 'arm's length' association with the institution he founded, some collectors make their private possessions available to the general public in galleries and museums that are the equal of many national collections.

The John Paul Getty Museum in Los Angeles houses an overwhelming collection of artworks as well as artists' papers and drawings, and through the bequest of its billionaire founder enjoys

a huge acquisitions budget that outstrips many national institutions. The Guggenheim is another private institution, which, like Tate, has expanded to include sites in New York in Museum Mile (Fifth Avenue) and SoHo, and in Venice, Bilbao, and Las Vegas.

The Getty has two museums – a replica Roman villa based on one found at Herculaneum and a brand-new museum complex occupying the top of a hill in Brentwood, Los Angeles. Here, the sprawling range of buildings, designed by Richard Meier, all cased in striking white Travertine brought from southern Italy, rival the contents of the museum itself. Similarly, the first Guggenheim museum was designed by Frank Lloyd Wright in 1960 – like Meier, one of the most famous architects of his generation. The unique white spiral shape of the museum made a distinct statement, sitting on one of the most expensive streets in Manhattan and only a few hundred yards from the Metropolitan Museum of Art. Since then Frank Gehry's striking titanium-clad design for the Guggenheim in Bilbao has perhaps played as important a role in attracting visitors as the museum displays housed within. The point here is not to propose that the buildings are taking over from the collections, it is rather to show how much we invest in these institutions. And that the private and public art museum and gallery can play an equally important role in the display and consumption of art objects and in the cultural life of a society through its presence in the (usually) urban environment. The institutions also play an important role in the shaping of taste and the way in which art history is presented and understood by the public at large.

A brief consideration of how collections were formed in Europe shows the ways in which art objects were historicized as a result of the activities of patrons and collectors. The beginnings of the idea of collecting objects goes back to Ancient Greece. The *Mouseion*, meaning 'home of the Muses', was a building that housed artefacts that honoured these nine goddesses who personified the arts and sciences, and the word museum comes from this religious practice.

The Romans were keen collectors and formed large collections of objects as offerings in temples and sanctuaries that were seen by ordinary members of the public. At this time the idea of private collections also emerged; some of these, for example the display of art at the Emperor Hadrian's villa at Tivoli, just outside of Rome, were really quite splendid.

The idea of amassing diverse collections of objects, some from past times, others from the present, came to the fore in the early modern period. In the 16th and 17th centuries the cabinet of curiosities – a small private collection of objects ranging from prints and drawings to scientific instruments – became the 'must have' item for those who could afford it. The collections of antiquities and great works of art owned by Italian Renaissance princes and popes were seen as signifiers of their status, wealth, and cultural worth. We have already seen how Pope Julius II founded the Vatican collection of ancient sculpture with the *Apollo Belvedere* (Fig. 7). Alongside this papal patronage was the impetus behind some of the best-known works of the 16th and 17th centuries – the Sistine Chapel ceiling by Michelangelo, the Vatican *Stanze* by Raphael (see Chapter 2), *The Baldicchino* in St Peter's by Bernini, and the cathedral itself, which was the work of many famous architects including Michelangelo and Bernini (we must remember it was not at all unusual for artists to also practise architecture at this time). This huge collection of art from antiquity and the Renaissance was a major attraction for visitors to Rome interested in art history – and this is still the case.

The idea of owning objects from the past became even more popular in the 18th century. This was partly due to the increase in travel in the period, especially the Grand Tour – an educational pursuit for young men, who travelled Europe to see the principal sites of cultural interest. Rome was a focal point of the tour, and English travellers would gather at the Caffe degli Inglesi to exchange news from home. Most of us like to buy souvenirs when we visit somewhere of interest; 18th-century tourists were no different in that they also wanted souvenirs, and they were able to bring back

paintings, sculptures, drawings, and so on to form or embellish their own personal collections. The sculptures of ancient Rome were particularly popular, many items being pieced together from fragments of different sculptures – but the eager customers did not seem to notice or to mind about this. Artworks in English country houses are testimony to this passion for collecting, and references to these collections and knowledge of the art of ancient Greece and Rome became a part of what we might call 18th-century popular culture.

Sir Joshua Reynold's 1773 portrait of the Montgomery sisters, *Three Ladies Adorning a Term of Hymen* (Fig. 13), shows how these allusions to the classical past were used to embellish the status of those who commissioned works of art and those who were their subject. The portrait was exhibited at the Royal Academy by Reynolds in 1774. Reynolds was one of the founders of the

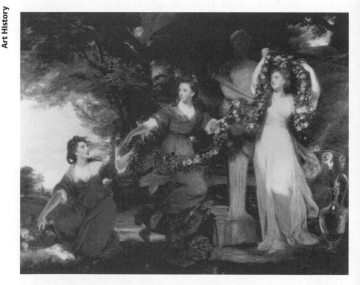

13. Sir Joshua Reynolds' portrait of the Montgomery sisters, *Three Ladies Adorning a Term of Hymen*, was exhibited at the Royal Academy of Art in London in 1774.

Academy in 1768 and he intended that it should be an engine for the display of art by artists. (The Summer Exhibition at the Royal Academy in London remains a busy marketplace for contemporary artists to sell their work.) Reynolds' picture is an unusual combination of a portrait and a history painting, and this is important for us as it shows how closely history – or at least the fascination with the classical past – formed part of the image of 18th-century elite society. A classical sculpture is represented in the figure in the middle of the picture space – this is Hymen, the god of wedlock, making reference to the art of ancient Rome and its mythological literature. The painting also makes reference to the classical subject of nature, being adorned by the three graces (the personification of female virtues: chastity, grace, and beauty).

The Royal Academy was the main means through which artists could present their work to other artists and potential patrons, as well as where they learned their trade in the Academy school. The different subjects of painting were placed in a hierarchy and artists ranked according to their talent in relation to these. In this academic system, the best artists painted the most important kinds of pictures. History painting was seen as the pinnacle of artistic production and usually referred to ancient history or mythology (as we have seen in Reynolds' portrait). In Protestant countries such as Britain, biblical subjects were not as common in art as they were elsewhere in Europe. But representations of biblical events were considered as equal to history painting in the academic hierarchy of subjects. History painting was more prestigious than portraiture, which was followed by genre (scenes from everyday life), and landscape. The idea of the Academy is important to art history as it was one of the first locations where art was presented to a select public. Vasari, who as we have already seen was very influential in the development of writing art history, founded the first academy of fine art in Florence in 1563 under the figureheads of the Grand Duke Cosimo de' Medici and Michelangelo. Vasari intended his academy as a means both to

augment the social status of the artist and to offer training. Other Italian cities soon followed his example, with the Accademia di S. Luca being founded in Rome in 1593 and the Bolognese Academy in 1598.

In 1648 France founded its own academy, the Académie Royale de Peinture et de Sculpture, which soon became an engine of the publicity machine of the monarchy. Like the Royal Academy in London, it offered training and graded artists according to the form of art they practised. In recognition of the enduring importance of classical and Renaissance Italian art, a French academy in Rome was established in 1666, which facilitated the direct study of important works.

The passion for collecting and travel, together with the academies of art that came into being across Europe in the 'long' 18th century (c.1680–1830), ensured the predominance of classical art. Sculptures were studied by art students as a way to learn how to equal the art of the ancients. Where originals were not available, or to increase students' exposure to the great works of the ancients, copies or casts of sculpture from prominent collections like that of the Vatican were available in academy schools. We have already seen the effect of the ancient world on historians like Winckelmann, and here we see those ideas being translated into artistic practice. The importance difference is that Winckelmann studied ancient art through texts. Here it was being studied through direct experience of either the original or an accurate cast copy. This visual method of presenting art history, together with the displays of contemporary art in academies, had important implications for the development of museums and galleries.

The increase in wealth and education across Europe had an effect on the number of people interested in art. This is seen in the growth of the art market – where artefacts from past and present were traded as items that reflected the owner's status and wealth.

Obviously, paintings and sculptures were the most prestigious items to purchase, and as we have seen there was a very brisk trade in antique sculpture (or sculptures made up of fragments of various works from classical times). For those who had less money, prints and drawings became very desirable possessions, and this trend was encouraged by the growth of art dealers who displayed copies such as these in their shop windows, as well as using newspaper advertisements and sales catalogues.

The Royal Academy in London and its many European counterparts, notably the Salon in Paris, organized exhibitions of their members' works, which were offered for sale – a practice that continues to the present day. But more than this there was also an interest in art becoming more publicly accessible. Up until this time, cabinets of curiosities and private collections held in family homes or royal palaces were seen only by those who were invited to do so. By the 18th century, public exhibitions and museums were in great demand; the growth in the art market had changed the relationship between art and its public. The private, amateurish collectors with their cabinets of curiosities were overtaken by an increasingly professional art market that promoted the careers of artists through exhibitions and the growth of national institutions. Donations from monarchs, princes, and the elite helped build up these collections and ensure national prestige, but alongside this their private collections became available to an increasingly broad public. This too could be seen as a form of national patrimony and good government. In the latter half of the 18th century, private princely collections were opened to the public across Europe, in Paris, Rome, Florence, Dresden, and Stockholm. It is important to understand that these were not open-access museums like the ones we are used to today. But for the first time a wide selection of art was available to a much larger audience.

One of the first public museums, as we understand the term, was the Louvre in Paris. It was founded in 1793 when the French Revolution was at its height. The opening of the royal collection of

art treasures and the royal palace itself to the public was seen to represent the ideals of liberty, equality, and fraternity that underpinned the Revolution itself. But it was not long before the snobbery that can be associated with 'high art' began to manifest itself. Very few people from the poorer classes visited the Louvre, and their lack of knowledge about what they were looking at and inability to respond to visual works in an appropriate way was criticized by their middle-class 'brothers'. The Louvre was a catalyst to the development of publicly accessible collections, and with it came a wish for a history or narrative of the art that was presented in these museums and galleries; moreover, national institutions were seen as a means of educating and improving the minds of the general public, so the history presented within them was an important way of doing this.

In Britain, where civil unrest was feared (as a consequence of the French Revolution and also as a result of the poverty and deprivation that attended the Industrial Revolution), visits to art galleries by the working classes were encouraged as a means of keeping the peace, by encouraging feelings of patriotism for national collections. These collections were not always of indigenous artefacts, for instance the National Gallery in London was founded on the Angerstein Collection, which comprised mostly pictures from Renaissance Italy rather than works by British artists. Similarly, the British Museum housed mostly Graeco-Roman antiquities. But these were still seen as markers of national prestige. The Victoria and Albert Museum is an important example of this trend. Founded in 1857, it contained all manner of artefacts from crafts to mass-produced goods, which were presented to the general public to try to establish good standards of taste. Alongside this, the ever-expanding collection of high art – paintings and sculptures – from the British Empire was displayed as a reminder of the prowess of Britain and the extent to which it then ruled the world. In this way we can see how the art history of non-Western cultures was subsumed into a narrative about the importance of Britain. These objects' only function was the part they played in the embellishment

of the image of Britain. They had no history in their own right – an issue in art history that we have already discussed in Chapter 2.

These London institutions were indicative of a Europe-wide phenomenon. In the latter half of the 19th century, in addition to these public institutions, world fairs became an important instrument in putting art and national identity on view. These were huge events where the art and artefacts of the world were represented in such a way that they became part of some larger narrative – perhaps endorsing the idea of empire or the notion of progress in the industrial age. This deliberate ordering of objects related to Hegel's idea of history, where the spirit was manifest in art.

My discussion so far of the ways in which art history has been presented has concentrated on European traditions. It is clear that there is a link between methods of displaying art, the kind of art in these displays, and national identity. We have also seen how American collections and art institutions were mapped onto this European model. It was only in the second half of the 20th century that American art began to emerge from its isolation and somewhat provincial position on to the world stage.

The Federal Art Project (1935–43) was set up under President Roosevelt's New Deal – a response to the Great Depression of the 1930s. This has some similarities with the academies that were established in Europe in the preceding centuries, as many artists gained vital experience and improved social status as a result of their involvement with the Project's public artworks, including murals and work in public buildings. Jackson Pollock and Willem de Kooning both benefited from this scheme. At the same time, the growth of private galleries in New York – art dealers who sold the work of major European figures such as Salvador Dalí and Piet Mondrian – ensured there was plenty of stimulation for these American artists. Alongside this, public collections of modern art (mostly European) were accessible in the Museum of Modern Art in New York, which was founded in 1929. The national style promoted

by the Project was initially rather like Soviet Socialist Realism, but the contact with the Surrealists encouraged Pollock to experiment with Abstract Expressionism – a European movement that denied the influence of canonical art through its painterly, non-figurative effects. Although this direct government funding of art ended in 1943, in the post-World War II era realism was seen as too left-wing. Instead, Abstract Expressionism – or an American version of it – was seen as the art of the free world and this continued to enjoy state support, albeit of a more covert nature. Jackson Pollock's *Echo (Number 25, 1951)* hangs in the Museum of Modern Art in New York (Fig. 14). It is an example of Pollock's drip paintings, for which

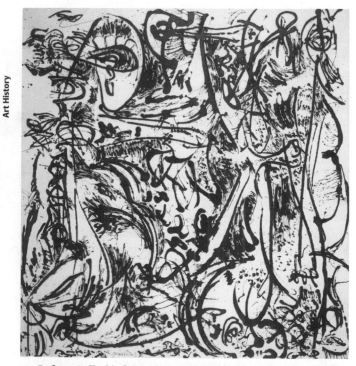

14. Jackson Pollock's drip painting, *Echo (Number 25)*, 1951, is now in the Museum of Modern Art in New York.

paint was dripped from a brush or stick onto a canvas that was laid out on the floor. The movement of the painter's arm created patterns over the picture's surface. Although this is quite improvisatory, it also allowed Pollock control over the finished work. The technique was influenced by the Surrealist idea of 'automatism', a kind of spontaneous drawing that came straight from the artist's subconscious. The description of this technique indicates the way in which the traditional academic reliance on reason and rationality was removed from the process of art. Instead, the canvas became a record of an artist's own creative processes.

Museums and galleries have also played an influential role in the endorsement of or challenge to the canon of art history. In order to understand how this has come about, it is necessary to think more generally about the relationship of museums to the past. If we reflect that history is how we refer to the past as well as the process of studying it, we begin to see that museums and galleries can act as important mediators in the relationship between people and their history. Museum displays essentially take a set of objects in order to compose or reorder them for us as we see them in the present. Gallery spaces contain exhibits that are linked by systems we have set up – whether it be the artists, style, school – and not by connections that were relevant at the time of their production. This is a key point to understanding that the act of presenting art history in these spaces is about presenting a past that relates to the present. In this way, art is commemorated in a museum and we are able to read it as we would a book, as it has a beginning, middle, and end. This kind of rational, orderly piecing together of the past does in many ways act like a novel, with the story gradually unfolding. As a consequence, museums tend to endorse our social and cultural *status quo* by projecting how we are at this moment on to the presentation of the past.

This is not just a dry and theoretical analysis of the museum. The changes there have been in the layout of displays in permanent

collections are testament to the way in which museums and galleries act as barometers of current trends in thinking about artefacts and collections. One of the most notable recent examples of this are the new hangs at Tate Modern and Tate Britain. Here, instead of the chronological display of works according to period and school, we find works hung thematically. So, for instance, there is a room that shows images of the female nude as depicted by a range of artists from across a broad period of time. The only connection between these images is the subject matter and, of course, that they are in the Tate collection. These pictures were previously displayed as part of a different 'narrative', or presentation, of art history. This new presentation is not because art history has changed, but it shows a different negotiation between us, the present-day viewer, and the past. The means of doing this – the narrative thread, to continue the analogy of the novel – tells us something about our current preoccupations. We might say, for instance, that the thematic display is indicative of the fact that we are no longer so preoccupied with who painted the picture – the artist – and breaks with the tradition of seeing artworks being very closely linked to their makers. Similarly, we might also conclude that in this case the grouping together of female subjects re-examines the role women have played in the art world. Feminists have said that women had to be naked to get into an art gallery. So is this new kind of display perhaps an acknowledgement of the preoccupation with the female nude by male artists and patrons, and the concomitant absence of women artists from the historical narrative of art history?

What I want to do now is to assemble, or if you prefer curate, a couple of 'mini exhibitions' to demonstrate the points made in this chapter.

The first 'mini exhibition' addresses the theme of 'woman'. This subject is common to art from all periods and cultures. I am selecting the following from the illustrations in this volume: Leonardo's *The Virgin and Child with St Anne and St John*

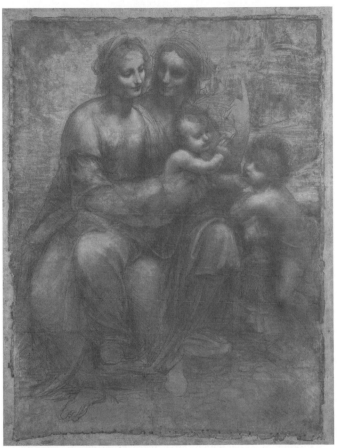

15. *The Virgin and Child with St Anne and St John the Baptist* by
Leonardo da Vinci (*c*.1500).

the Baptist (Fig. 15); Vermeer's *Maid with a Milk Jug* (Fig. 16);
Reynolds' *Three Ladies Adorning a Term of Hymen* (Fig. 13); and
finally a 19th-century female statuette in wood from the Ivory Coast
(Fig. 11). The most striking thing about this selection is the various
roles women can represent. In Leonardo's image we see the
maternal role of 'woman'; Christ's mother the Virgin Mary looks

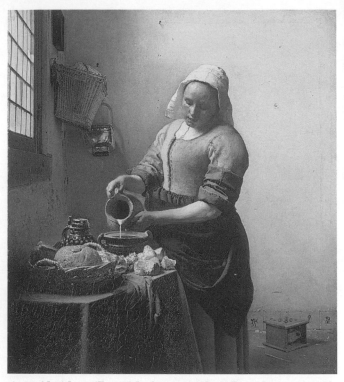

16. *Maid with a Milk Jug* (also known as *The Milkmaid*) was painted by Jan Vermeer around 1658–60.

dotingly at her son whilst at the same time being watched by her own mother, St Anne (who is also Christ's grandmother). Vermeer shows us 'woman' as a servant doing housework – a model of feminine 'domesticity'. By contrast, Reynolds' portrait of the three Montgomery sisters tells us about 'woman' as spinster, fiancée, and bride. The sister kneeling on the ground on the left of the picture is unmarried and picks flowers for the garland that is to adorn the term of Hymen (the classical sculpture representing the god of marriage). The sister in the middle, who seems to be moving up and towards the third sister and passing the garland to her, has recently

become engaged (the painting was commissioned by her fiancé The Right Hon. Luke Gardiner), whilst the third sister on the right-hand side of the picture stands holding the garland above her head. This sister is already married; she stands on the other side of Hymen, indicating her fulfilled status as wife, and the lighting in the picture falls onto her breasts and abdomen, rather than her face, highlighting her sexuality. Our small exhibition concludes with the statuette from the Ivory Coast. We don't know if this is a portrait or a representation of the idea or ideal of woman. In either case female sexuality is most certainly of paramount concern in this work.

The second 'mini exhibition' is about 'man', once again assembled from illustrations in this book. I have selected the following images: a manuscript illustration of the *Four Evangelists* (Fig. 17); Raphael's *School of Athens* (Fig. 9); *Apollo Belvedere* (Fig. 7); and sculptures from Easter Island (Fig. 18). The Evangelists, Matthew, Mark, Luke, and John, are the authors of the four gospels that appear in the New Testament of the Christian Bible. Their writings are fundamental touchstones of Christianity, and show us the importance of men as proactive makers of religion. In the *School of Athens*, we see a large number of philosophers and thinkers from ancient times, all of whom have been celebrated for their intellectual ability and contribution to human knowledge from antiquity to the present day – and all of whom are men. The *Apollo Belvedere*, as we have seen in Chapter 1, represents the paradigm of male beauty. The physical perfection, although nude in the Greek original, is shielded by a strategically placed fig leaf. Finally, although the Easter Island statues remain enigmatic, recent theories suggest they are of tribal chiefs, warrior leaders, or gods who represent authority.

To sum up our two small exhibitions, 'woman' shows images of maternity, domesticity, matrimonial status, and sexuality. By contrast, 'man' includes images of the religious leader, thinker, secular leader, pagan deity, and warrior.

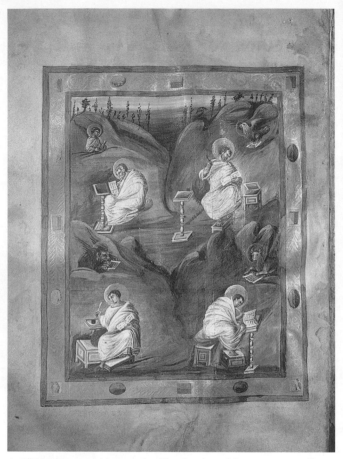

17. This 9th-century manuscript illumination of the *Four Evangelists* – (anti-clockwise from top left) Matthew, Mark, Luke and John – is from a Carolingian gospel book in Aachen Cathedral, Germany.

It is important to emphasize that this exercise is not confined or determined by the illustrations selected for this volume – or indeed the themes I chose to explore. This can easily be tested, as Internet access is possible to most of the major collections, many of which have excellent interactive websites (the web addresses of some of

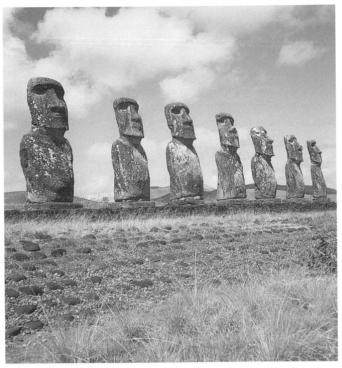

18. **Ahu Akivi, Easter Island, with its seven statues. The figures may represent tribal chiefs, warriors, or perhaps gods.**

these museums and galleries appear at the end of this book). A search of these sites using a key word that is a theme for a possible exhibition, for instance 'Greek mythology' or 'still life', will yield a range of images. The connective tissue between these may not be anything to do with style, authorship, or the idea of the chronological progress of art.

Alongside this function of the presentation of art history as representing the concerns of the present, we can also see how the museum functions as a way of legitimizing new art into the canon of the Western tradition. Tied in with this is the idea of progress – that

each generation continues the process that works towards endorsing the current status quo. In this way, we can begin to identify the moment when art becomes art history and the role of the museum in effecting and presenting this. Sir John Summerson, usually associated with architectural history, gave an inaugural lecture when he became Ferens Professor of Fine Art at the University of Hull in 1960. His remarks are very helpful to us in thinking about this point:

> new art is observed as history the very moment it is seen to possess the quality of uniqueness (look at the bibliographies on Picasso and Henry Moore) and this gives the impression that art is constantly receding from modern life – is never possessed by it. It is receding, it seems, into a gigantic landscape – the landscape of ART . . . which we see through the window of an observation car, which is so like the *vitrine* of a museum. Art is behind glass – the history of glass.

This is an important issue as it is about the transition of an art object from a newly created work at the cutting edge of contemporary culture to something that begins to be part of the history of contemporary culture – no matter how recent. This also relates to the idea of art criticism as discussed in the opening chapter of this book. Contemporary art practice can be dominated by art criticism as the principal means of discussing it and evaluating its worth – in artistic and monetary terms. But once works by artists like Damien Hirst or Tracy Emin become part of an art collection, be that public or private, they transgress the boundary between art and art history.

We tend to accept that if an object has been purchased or donated to a large museum it is conferred with an aura of authority and status. The institution acts on behalf of society to recognize art or interpret the work as art and to then present it to the public. This might not always be a straightforward process. Controversies over the purchase of artworks are frequent. The minimalist artist Carl Andre is a case in point. In 1967 Andre, a sculptor, filled the Dwan

Gallery in Los Angeles with a layer of concrete blocks and then removed rectangles, so leaving 'negative' shapes. His sculpture was defined by this cut space, which related to the gallery. This exploration of the relationship between object and gallery was furthered by Andre in 1976 in a series of eight sculptures *Equivalent I-VIII* made out of fire bricks. The shape of these works related to the negative shapes Andre had made in Los Angeles. The Tate Gallery, as it then was, purchased *Equivalent VIII*. The public outcry over the use of funds to purchase 120 previously made, standard bricks was loud and long-lasting. In addition, the fact that the sculpture was long and low to the ground – easily missed on first glance – gave it little immediate aesthetic appeal. But Andre was making a statement about the traditional expectation of sculpture to be vertical and figurative. Moreover, his work takes its form from the spaces of the gallery, and the display of *Equivalent VIII* in the Tate confers to it the status of art.

The relationship of the museum to its public is, then, really quite complex. On the one hand museum curators and directors might expect only those who 'know' about art to attend their institutions. But can they then be called public museums? Other directors argue that the visitor needs no prior knowledge of art to understand and appreciate artworks – it is an aesthetic pastime that anyone can enjoy who likes to look at artworks. These are the two opposing opinions, and there are plenty of points of view in between. But what are the consequences of these attitudes? If a museum or gallery is to try to broaden its appeal, what strategies should it undertake?

I have already talked about the way in which the display of objects according to style or school, usually represented in chronological order, can enforce the kind of teleological systems that have dominated art history. But there is a popularist element to this: for instance when the Musée d'Orsay opened in Paris in 1986 an historical mode of display was chosen as it was thought this would have the widest possible appeal. But this is more easily achieved

where there is a distinct historical narrative of progression – in the case of Orsay from French Academic painting of the mid-19th century through to Manet and the Impressionists, and then to the Neo-Impressionists and Post-Impressionists. It all works rather well as a neat, tidy bundle, and the museum building itself is a converted former 19th-century railway station, so adding to the 'authentic' historical experience of the art of that time.

Art from the later 20th century onwards sometimes creates issues that have to be dealt with as regards accessibility for the general public and the way in which works are displayed. Displays of what I shall call here 'modern' art in museums have broken away from the traditional formula seen in the Orsay, the National Gallery in London, and a host of other large institutions, some of which I have mentioned. From about the 1980s, museums of modern art have devoted whole rooms or spaces to the work of a single artist and have broken away from linear arrangements of works to try to create a gallery experience that is primarily visual. It's possible to recognize here a distinct similarity between the methods of displaying modern art and the way in which its histories are written. In Chapter 2 I talked about Clement Greenberg and his ideas about the status of avant-garde work; here we have that kind of 'hero' worship in action in the gallery. The individual artist, who may be alive and still producing work, may find him- or herself in a gallery space where they feel their work is part of that space.

Alongside the permanent collections in museums and galleries, the special exhibition which often tours from country to country or across continents gives the general public access to an even wider range of art objects. Art history can be presented in quite a different way in these shows. Curators can pursue themes or ideas or the life of a particular artist as they can draw on the holdings in collections worldwide, provided the owner-institutions are willing to lend. These kinds of exhibitions are important ways in which art history can be presented, and they have affected the way in which we think about the subject. One of the most famous examples of the

interaction between exhibitions and art history was the show organized in 1910–11 by the English art historian and critic Roger Fry, who returned to Britain after being Director of the Metropolitan Museum of Art in New York for five years. The exhibition included works by Van Gogh, Gauguin, and Cézanne, all of whom worked in very different styles. Fry called the show 'Manet and the Post-Impressionists', thereby naming a 'new' artistic movement which remains today a very popular subject in art history. The new name, or category, was even adopted by the French and translated as *le post-impressionnisme*. Unlike Impressionism or Romanticism, Post-Impressionism does not principally refer to the stylistic similarities between artists; instead, Fry wanted to group together those who were interested in a more formal conception of art and who stressed the importance of the subject. 'Manet and the Post-Impressionists' caused a great deal of controversy, but the idea of the 'blockbuster' exhibition grew out of events like this. These kinds of travelling or one-off exhibitions are unique experiences. The coming together of artworks from across the world enables a presentation of art history in which the subject – our primary evidence – remains centre stage.

Chapter 4
Thinking about art history

One of the most interesting aspects of art history is the way in which it enables us to think about the ideas of a range of writers and theorists and in turn how their work has interacted with the visual. I want here to show you briefly the ways in which art history can incorporate the richness of Western thought into the analysis of visual subjects. The term 'Western thought' is used purposefully only to prescribe the limitations of my discussion.

In Chapter 1 I discussed what we mean by the term art history and I distinguished it from art appreciation and art criticism. One of my main points was that for art to have a history there has to be some kind of method or approach to the way in which the narrative or story of art history is put together. In other words, putting art objects in chronological order or in stylistic groups is not enough. The way in which a range of schools of thought and philosophical ideas have been used to put together these narratives of art is an important part of art history. I am not calling here for some slavish devotion to theory at the expense of the objects themselves – to do that is as meaningless as putting art in chronological order. In Chapter 1 I suggested that the work of art is our primary evidence, and it is the interaction between that evidence and our method of enquiry that is the substance of art history. This chapter builds on the discussion in Chapter 2 where the various traditions of writing art history were considered. Here the different ways of thinking

about art history – its social, cultural, and aesthetic meaning – are the focal points of discussion. Clearly, these are related topics, but Chapter 2 concentrated on selected works and writers. Here we see how art history relates to and forms part of a broader discourse around the historical formulation of issues such as class and gender.

We have already seen how writers such as Winckelmann helped found the discipline of art history. But at the time when he was writing, the status of visual experience was generally considered inferior to human thought. The fundamental problem with this paradox is that art history should rank second to other kinds of history or, perhaps more accurately here, other kinds of knowing. The rational scientific idea of knowledge that predominated in the 18th century was that thought was superior to sensory knowledge. It was an extension of Descartes' notion of *cogito ergo sum* – I think therefore I am – humankind's ability to reason made up the core of our being. By the mid-18th century this hierarchy of knowledge was being challenged and as a consequence ways of thinking about the importance of art history changed. One of the key developments was the appearance of the term 'aesthetics', a mode of thought that considers sensory perception as equal to rational or logical thought. Logic is based on verbal reasoning, whereas aesthetics is based on the senses, in our case sight. This goes back to one of the questions raised right at the beginning of this book about the problems of writing about visual experience – the art we experience through sight, but articulate using words. The language we use to describe art objects can be at odds with our experience of the objects we see.

One of the first philosophers to think about these issues was Alexander Gottlieb Baumgarten. He wrote a lengthy treatise in Latin on the subject, entitled *Aesthetica* (1750–58). This put art, for the first time, within a framework that did not have any hierarchies. Beauty equalled perfection, but here this was perceived and understood by the exercise of taste (in this context taste means a very clear sense of perception) rather than reason. This challenged the idea that the purpose of art is to imitate nature, which was

fundamental to the system that had been set up by Winckelmann. Instead, art should create sensory knowledge by forming perfection out of indistinct images. The most important point to take from Baumgarten is the idea that an individual's judgement or taste about aesthetics could have value and meaning to other people.

This is the cornerstone of Immanuel Kant's *Critique of Judgement*, published in 1790. Kant analysed our ability to make individual judgements about aesthetics, and described the way in which he perceived that these judgements underpinned the concept of 'genius'. A judgement about the quality of an artwork would be made in terms of its beauty and purpose. Kant's notion that there could be a range of aesthetic tastes, in contrast to Winckelmann's hierarchical system, also encouraged the view that beautiful objects arouse our sensations in the same way as moral judgements do. In this way, aesthetics and ethics become intertwined and the concepts of genius and taste are intrinsically linked with the moral character of the artist or viewer. Kant's ideas squarely challenged the supremacy of the classical ideal championed by Winckelmann.

Kant's idea of the aesthetic was refuted by that most influential thinker about history and in turn art history – the early 19th-century German philosopher G. W. F. Hegel. Hegel is sometimes referred to as an idealist or metaphysical thinker because he believed that all events are part of a process that leads towards a self-knowing divine spirit. For Hegel, this spirit was the inner nature of the world, which expressed itself through the spirit of the nation, or *Volksgeist* as it is known in German. The spirit is also manifest in the spirit of the age, or *Zeitgeist*, as discussed in Chapter 2. These two elements constitute the always-moving dynamic of history. Hegel wanted to understand the entirety of history as both a system and an ongoing process. Although he saw sensory experience as a debased representation of knowledge, art remained for him one of the most important means of seeing and understanding history as the spirit. The history of the spirit can be broken up into three periods – the symbolic, the classical, and the

romantic. These three periods relate very neatly to the way in which art history has traditionally been divided up – first there is non-Western and early art; second there is the Graeco-Roman tradition, which we sometimes also call classical art; and finally there is the art of Christianity and German Romanticism, coming to the fore at the time at which Hegel was writing. This period, as far as Hegel was concerned, was the end of art, as this epoch would be absorbed into the spirituality of Christianity. Despite the strong religious underpinning in Hegel's thought, Graeco-Roman art remains the central plank of a Hegelian view of art. And like many other writers, including Winckelmann, he uses Greek art as a means of defining beauty. In each of Hegel's three periods there is a beginning, middle, and end, at which time art reaches perfection and then goes into decay. In the case of the art of Graeco-Roman times, perfection could be found in the early beginnings, referred to as the Archaic period – as seen for instance in the stillness and serenity of the figures on the Parthenon frieze, and went into decline with the decadence of the Hellenistic period, when the human figure was shown in a much more emotional state of movement. Although Hegel places great emphasis on the bigger picture of art history, he also thought it important to look very carefully at the objects themselves in order to understand them fully. That said, he did not think that art history was all about connoisseurial values. Instead, art objects were, in his view, very much a part of a larger historical process.

Hegel has been extremely influential on the way we think about art history as a systematic enquiry into historical knowledge. Although his concept of the spirit or divine was rooted in Protestant Christianity, his ideas paved the way for historians to pay less attention to religious art, which was a mainstay of artistic production in the West, and think instead about the idea of progress and how society is represented in the art forms it produces. In other words, how art operates as part of the Hegelian 'spirit of the age', which is his explanation of history. If we think about this in relation to Reynolds' *Three Ladies Adorning a Term of Hymen* (1773), which

has already been discussed in Chapter 3, we can think about this painting in terms of the later 18th-century preoccupation with antiquity and how the values of that society were adopted and used as a model for their own. This spirit was also manifest in the architecture, literature, music, and other cultural outputs of a society that considered itself equal to that of the ancients.

Karl Marx, perhaps one of the most important thinkers of recent times, was also significantly influenced by his 19th-century contemporary Hegel. Marx's analysis or approach to history largely followed the model developed by Hegel. Cultural forms – including art – change throughout history and the manifestations of the spirit. But for Marx the spirit was not some real entity or ideal, it was instead the economic basis for society. This relationship between the economic base and the product or superstructure (in this case art) is known as historical materialism. Marx argued that everything around us is determined by our social class, and that as a result there are many historical 'truths' depending on your class or cultural viewpoint. Leading on from this, Marx introduced the notion of 'ideology' to examine our relationship to art. Ideology is all to do with the manipulation of power, and for Marx there are always two social groups: the exploited and the exploiters. For Marx, then, art was about the dynamics of power operating between these two groups. Art is part of this concept of ideology as it influences the relationship between us and our context. It makes us think about ourselves in a certain way. This can be explained in more detail, and to demonstrate the connection between Marx and Hegel I will use the same example of Reynolds' *Three Ladies Adorning a Term of Hymen*, 1773 (Fig. 13). If you think back to the discussion of the Grand Tour in Chapter 3, I talked about how collections of artefacts of ancient Greece and Rome became part of the must-have items for the elite and how this trend helped to promote the popularity of the classical revival in art. The interest in antiquity can be identified as part of the 'spirit of the age' in 18th-century Britain. This 'spirit' is manifest across all forms of cultural production. For instance, many of the country houses in this period were designed using

architectural elements copied from ancient Roman buildings. In this way these objects were part of the ideology of a certain class, and this relates to Marx's idea of a belief or value system. If you appreciated them, understood them, and best of all owned some of them, you were part of this social group. Here, membership of this group is based on wealth; certainly the artefacts from antiquity were expensive, and so money underpinned this cultural activity.

For Marx there is an essential relationship between economic structures and the culture of a society. It is the social production and consumption of art that matters rather than the individual artist or patron. One further example is helpful here. In Chapter 1 I talked about John Constable's *The Cornfield* (1826), an idyllic representation of the English countryside that has enjoyed enduring popularity. But this depends on who is looking at it. For those members of early 19th-century society who had been displaced from their rural communities as a result of the Acts of Enclosure and the Industrial Revolution, this image must have seemed remote from their everyday experience. *The Cornfield* presented the ideology of a rural idyll – but it was land owned by the elite. The notion of ideology as a basis for power has been an important tool in the way art history has been written in the last few decades and I present some examples of this later in this chapter.

Hegel and Marx show us how in the 19th century there was great interest in the idea of history in both meanings of the word – the events that happened in the past and the study of them. Both their ways of thinking about art are important as they enable us to see art outside of the context of individual artists and patrons; instead it is more of a barometer of social, cultural, and political forces – in other words external pressures and influences. And as we have seen in Chapter 3, the 19th century was an important period in the formation of museums and galleries. The attitudes of these institutions towards history and aesthetics when presenting art history ran parallel to and intersected with these ways of thinking about art history.

The divergence between the formalist or aesthetic critique of Kant and the contextualizing frame provided by Hegel and Marx has remained a mainstay of art history through to the present day..This is particularly evident in relation to our preoccupation with the meaning of objects and how this meaning is conveyed. These concerns converge around the idea of a semiology of art. Semiotics is a long-established strand of philosophical enquiry that was initially concerned with language and communication. Its beginnings in art history are seen in the work of scholars such as Erwin Panofsky and Aby Warburg, as well as Ernst Gombrich, whom we discussed in Chapter 2. For these art historians, semiotics was seen as commensurate with iconology, and was concerned with the analysis of content rather than form. I discuss this in more detail in Chapter 5. In the first half of the 20th century, iconology was a distinct way of thinking about art that concentrated on connecting visual imagery with other kinds of cultural outputs. In more recent times, it has become a looser practice that is more to do with thinking about the meaning of the subject matter of a work of art rather than its style or broader context.

Semiotics has become part of what is now generally referred to as critical theory – the academic theory of criticism. Critical theory is a collective term for structuralism, post-structuralism, deconstruction, psychoanalysis, and post-colonialism, to name but a few strands. These schools of thought are concerned (respectively) with the challenging of the notion of absolute truth and reality, the study of the human subconscious, and cultural production and thought in a world where the colonial imperative no longer has the sovereign status it once enjoyed. I have briefly mentioned New Art History, which is seen to be the champion in using critical analysis to think about the visual. I want to highlight a few of the important ways critical theory has influenced how we think about art history.

One of the most important texts in recent decades is Michel Foucault's *What Is an Author?* An innocuous enough question that really gets to the heart of our enduring preoccupation with the artist

as a genius. Foucault is considered both a structuralist and post-structuralist – both are schools of thought that look at systems and organization in culture and then use these systems to analyse those cultures. Foucault's argument is directed at our concerns about authenticity and authorship in relation to value and quality. Not only does this help us to separate out the meaning of a work from its author, but it also allows us to see anonymous objects as equally important signifiers of social and cultural practices. Art history is more than part of the personal biography of an artist. We do not know, for instance, who carved the Easter Island statues (Fig. 18), nor do we know who painted the manuscript illustration of the Evangelists (Fig. 17), but this does not necessarily impinge on our analysis of them. This should also be possible where the artist is known. For instance, if it were proved that Leonardo da Vinci did not paint the *Mona Lisa*, there would be no material change to the work. And if our analysis of its artistic and cultural significance is valid, surely these arguments would remain intact despite the work's anonymity. We also have to bear in mind that many artists ran large studios and used assistants or apprentices in their work. And, in the case of sculpture, some artists did not carve or cast their own work. For instance, Rodin's marble sculptures (Fig. 19) were carved by his workshop using his original bronze casts as models.

The ideas of 18th-century aesthetic philosophers such as Kant, who was interested in the aesthetic and in cognition, found their reprise in the latter half of the 20th century in the work of the French philosopher Jacques Derrida, who is generally referred to as a deconstructionist. Derrida is perhaps best known for his work on the practice of 'reading', where we are compelled to explore the ways in which things that may appear unified are also a series of contradictions. The implications of this practice of deconstruction for art history are quite far-reaching, and Derrida's first writings on the visual arts, *The Truth in Painting*, which appeared in 1978, sums up his ideas. Like his 18th-century predecessors, Derrida was concerned with the question of whether aesthetic objects

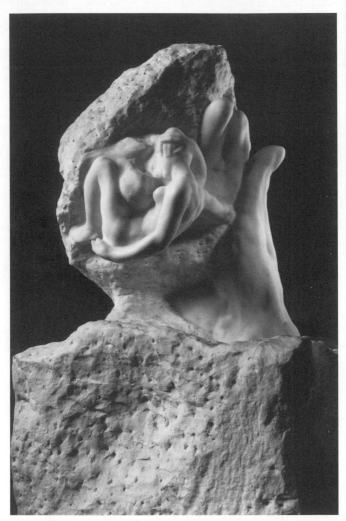

19. *The Hand of God*, 1896, by the sculptor Auguste Rodin. Rodin's marble works were carved by his workshops using his original bronze casts as models.

(paintings, sculpture, and the like) could be considered as autonomous, possessing their own 'code'. This 'code', in Derrida's view, is like other ways of thinking about art as having a meaning, just as we might think about the social or cultural context of art. It is really an issue of where the boundaries of a work of art lie. This enables us to think about the 'inside' and the 'outside' of a work of art, which can be a very helpful technique.

In *The Truth in Painting*, Derrida calls into question every aspect of a work of art. The notion of the 'outside' of a work includes, for instance, the frame of a painting or the signature of an artist on their work. But these categories go beyond the work itself to cover museums, archives, and the way in which art is bought and sold as a commodity on the open market. For Derrida all these impinge on the 'inside' of the work – the fundamental nature or aesthetic of the work, which is always modified by these external factors. As a result, Derrida sees the inside and outside as merging – both being forms of writing or graphic notation that can be read. In this way Derrida returns to Kant's ideas about cognition of an autonomous aesthetic that is distinct from pure reasoning. Like Kant, Derrida's argument for this distinction is an important touchstone for art and its history – that is to say art history as a discipline in its own right in which the aesthetic is a legitimate field of enquiry based on sensation rather than reason. If we look at Monet's *Rouen Cathedral*, 1894 (Fig. 1), we can begin to think about the consequences of what Derrida is saying, albeit in a rather simplistic way. The 'inside' aesthetic of the painting relies very much on sensation – the subject matter is self-evident and the work evokes the fall of light on the cathedral in full sun. The 'outside' of the picture is very much to do with the high market value on works by Monet, our preoccupation with him as an artist, and his prime position in many public collections. All of these 'outside' elements inflect on the way in which we see the 'inside'.

The 20th century – especially the opening decades – witnessed a growing interest in the human mind, and this facilitated ways of

thinking about art in a completely different way. Psychoanalysis is the study of the unconscious mind and was championed by Viennese psychiatrist Sigmund Freud. He used methods such as free association (the generation of a series of related ideas without focused thought) and dreams as a means of exploring the human mind. His ideas are now quite familiar to us – a slip of the tongue that reveals the speaker's hidden or repressed thoughts is often called a Freudian slip – and so it is hard for us to imagine how new and revolutionary Freud's ideas must have seemed at the time. Freud described the human self as comprising the id, that is the unconscious mind, and the ego, the conscious mind, the term with which we are perhaps most accustomed. He also proposed the idea of the Oedipal nature of relationships between children and their mother and, as we shall see, this has been a touchstone of different ways of thinking about art. To demonstrate what he meant, Freud used Leonardo da Vinci's *The Virgin and Child with St Anne and St John the Baptist* (Fig. 15). The appearance of the two women, Mary sitting on her mother's lap, was, according to Freud, the result of Leonardo's feelings of insecurity about the fact that he was illegitimate.

Psychoanalysis allows us to think about meanings in art that run parallel to those the artist intended when the work was made. This is important as it is a process through which we can separate the art from the maker. You might recall that the strong relationship between artist and art is a hallmark of a more connoisseurial approach to art history. Hegelian and Marxist ways of thinking about art instead place emphasis on context. Here, the processes and practice of art are seen to be an internal process of the artist's unconscious mind. We have already seen how Jackson Pollock's technique of painting was meant to connect the unconscious mind to artistic practice.

In this brief introduction to these ideas, my aim has been to try to provide some sense of how the visual can be a subject in its own right, the different ways in which we can think about it, and the

close relationship between visual and verbal forms of communication. All of this underscores how we think about art history and what the subject can bring to our understanding of culture and society, as well as ourselves.

The result of these various ways of thinking about art history is a range of schools of thought or approaches to visual subjects – each has a particular focus and invites us to think about the visual in a nuanced way. This can be very important for breaking down barriers between us, the viewer, and art that can at first appear inaccessible. Also, these approaches have been and remain very effective as a means of breaking down the dominance of the canon of art history.

By now Marxist historical, political, and social theory will be familiar – in name at least. Similarly, I have already mentioned at numerous points through this volume that feminism has influenced how we think about the visual, in terms of the way art has been used as a means of endorsing – and indeed challenging – a patriarchal society. Feminism has also made us think about ways in which women are placed and represented within society. I think it is becoming clear how these two ways of thinking about art history are related. Both rely on the notion of ideology and the sets of social relationships that this represents. In the case of Marxist art history, we have seen that the principal concern is class struggle, or at least the relationships between social groups. Feminism is concerned with the same kinds of principles, but with reference to the relationship between the sexes. Recently 'queer theory' has questioned gender as a socially constructed artifice rather than the biological destiny of the male and female sexes. This sheds a different light on social relationships and the ideology of art – indeed the two mini exhibitions I 'curated' in Chapter 3 demonstrate how gender can be constructed or determined through art.

In addition to these ways of thinking about art history we also find

approaches that are based on notions other than the dogmas of the philosophy of history. An important element here is psychoanalytical theory – how these modes of thinking are used to analyse the visual in order to construct social and sexual identity. We have seen this to some extent in Freud's analysis of Leonardo. Alongside this, we have the semiotic (also referred to as semiological) concepts which, along with structuralist methods of analysis, concentrate on art as being a sign that has to be decoded to reveal its meaning. The last two ways of thinking about art history are in part a process of disassociating art from its immediate historical context and play more on the meaning and interpretation of art. These are still valid practices within the discipline of art history – although some would argue against it. The visual is a rich topic that can be questioned in many ways. And these methods add to the expanding discourse of art history, rather than replace other ways of thinking about art.

There remains however, in all of these ways of thinking about art, one problem. How do we think about the aesthetic? This is a recurring theme to which I have returned at several points in this book, and to my mind it is one of the mainstays of art history. Without it, art just becomes another stepping stone or gateway into the past, a visual means through which we explore the social, political, psychological, or semiotic circumstances of the past (or indeed the present). But we run the risk of throwing the baby out with the bathwater if, as art historians, we try to deny that there is a category of the aesthetic and that to many there is such a thing as great art – however that is defined.

So what do we mean by the aesthetic? We have already discussed this in rather abstract Kantian terms. But a lay person's definition might include some recognition of the existence of beauty in art. Alongside this we might recognize the merit in making judgements in order to identify qualitative difference between different artists and their work. In addition would we also perhaps want to include the idea that looking at art can be a pleasurable experience. For

those of you who are 'new' to art history, this may well be your prime motivation in reading this book. Do we want to accept art is another ideology and its aesthetic just a part of it? I am aware of the very powerful arguments for this to be the case. Impressionist pictures, or works by Picasso or Van Gogh, sell for huge sums of money – is this not an example of the pleasure principle of the aesthetic at work? Or is it part of the process of buying into a social caste, just as the Grand Tourists did in 18th-century Britain? Are the paintings that sell for such huge sums and hang in company vaults as investments not just examples of the excesses of a capitalistic society? For most of us the chance of owning an expensive artwork is remote. We might instead enjoy a print, mouse mat, or screen saver of it.

In the next chapter of this book I want to introduce some ways in which artworks themselves can be the starting point for how we read art history. A combination of different ways of writing, presenting, and thinking about art history converge on the works themselves to show how important it is to not lose sight of these objects and how art can indeed have a history.

Chapter 5
Reading art

We have already seen throughout this book that there are many
questions we need to ask when we look at a painting or sculpture.
Here I want to think about how we answer the question 'what is the
meaning of this picture?', in other words to explore the levels of
meaning we can find in an artwork and the ways in which we can
begin to understand it. Throughout this chapter I use the term
'read' as the interplay between the verbal and the visual. It is
important to remember that art – a visual phenomenon – is
described, historicized, and appreciated using words. The visual
translates into the verbal and the meanings revealed become part
of art history. In bringing the discussion back to the artworks
themselves, the emphasis shifts to what we can read from the objects
rather than what we can read around or into them. These latter
ideas have informed the discussion in the previous chapters in this
volume and they are helpful here as they provide intellectual
contexts for art history. In this way we come back to the objects
themselves to see how subject matter, materials, and methods
combine in the process of reading art.

Artworks can be read on a range of levels that can be derived from
the objects themselves, and it is helpful to outline these. Perhaps the
most obvious starting point is the notion of the representational
meaning of art. The idea of representation in relation to art is often
connected with the perception of an image of the world we think we

see. Mindful of this, this chapter focuses on figurative art – that is to say work that represents something we think we see rather than an abstract image. There is no doubt that abstract or conceptual art has the same kind of representative qualities discussed here and that it can be read in a variety of ways. But in order to introduce these ideas, I am limiting my discussion to one kind of figurative representation – the human form. And it is true that certain periods appear more preoccupied with the representation of reality or nature of the human form than others. For instance, 17th-century Dutch art as seen in the paintings of Vermeer is considered to be realistic in its use of perspective and close attention to detail. Similarly, the interest in naturalism of Italian Renaissance art is evident in the treatment of the human body as well as of landscape – both of which were drawn from life.

But art is an illusion – paint on canvas, carved marble, or chalk on paper – it is what the viewer brings to it that makes it 'represent'. Clearly this act of reading is culturally determined – the reader or viewer's own cultural and social circumstances are inextricable from this process. We have already seen how this affects the presentation and interpretation of art objects in a global context in the opening chapters of this book. Here, I want to give some select examples to show that reading art is a necessary practice across all time periods. In other words it is our ability to read art that gives it its meaning, and this becomes an essential part of art history.

First there is the representational function of art where what we see can be connected with a larger narrative. This is exemplified, for instance, by the *Apollo Belvedere* (Fig. 7). At first glance this sculpture represents an athletic male nude, but we can connect this with Apollo as we understand the representational conventions being used – especially the laurel crown, which is associated with the god. In this way the representational meaning of a work will always remain general at some level as the sculpture gives the all-purpose idea of the idealized male nude which can be narrowed down to a more specific reference to Apollo. Sculpture

is a useful starting point to think about this because the physicality of the object delimits its representational meaning in several obvious ways.

Firstly, sculpture cannot signify any size beyond its own. By this I mean that the *Apollo Belvedere* is larger than human life-size, but we do not know if the artist intended to represent a giant – he is, after all, a god. The large scale could just as well be due to the original purpose of the work – perhaps to fill a large niche or stand up high. Secondly, the work does not represent space and has no 'setting' other than its immediate surroundings, whatever they may be. There is also an absence of colour and commensurate with this modelling of flesh and drapery. Clearly these limitations do not apply to all sculpture. Space can be represented in sculpture as seen, for instance, in the 'hole' that appears in many of the works by Henry Moore or in the spaces of the installation works of Mona Hartoum or, as we have seen, Judy Chicago (Fig. 8). Moreover, the use of a diverse range of materials by artists, particularly in the 20th century, both simplifies the question of representation, as the actual material can be used to represent itself, for example fabric, and makes the issue more complex as a range of materials can be used to represent an image as well as ideas about space and vision, as we have seen in Cubist collage for instance. My point here is to show that the problem of representation is a common one in art and not confined to specific periods such as the Renaissance or 17th-century Dutch painting where the apparent preoccupation with 'naturalism' or 'realism' can be misleading in this regard. The relationship between form and content is far more complicated than simply being able to recognize the world we think we see.

Secondly, it is important to think about how artworks can be the illustration of ideas or narratives, which are often based on textual sources. These sources can be illustrated in a variety of ways as verbal descriptions are usually much looser than a visual image. Illustrations of textual sources are far more specific or particular. The verbal descriptions of Apollo, or any other mythical figure from

the literature of antiquity, have been illustrated in a great variety of ways – the holdings of most major galleries and museums contain innumerable examples of this. We are able to identify these literary figures through certain attributes that provide a link between text and image – in this case Apollo's laurel crown. If the viewer had never heard of Apollo, or did not know how to identify him, the statue would remain only partially read – and some of its meaning would remain undiscovered.

Two things emerge from the relationship between verbal and visual descriptions. The first is that the diversity of ways of illustrating textual sources means that the text cannot be wholly reconstructed from the images of it. So although illustrations are more particular in terms of the image they present, they do not stand independent of their textual sources. In other words we need to know the text to read the image. Secondly, this impacts on the meaning of these illustrations as surely this cannot be fixed, but rather is influenced by the viewer and the knowledge they have (or not) of the textual sources. And we must not forget that the particularity of the image comes from the artist's own imagination. All of this establishes the artwork as a document or archive that has a complex relationship with text, history, and the culturally conditioned viewer.

I have not discussed the artist's intentions here as psychoanalytic models, as discussed in Chapter 4, have shown us that the meaning of a work can extend beyond its maker's intentions – if indeed these are known. The volatility of the meaning of images is a fascinating element of art history. But if we accept that art is a vehicle through which ideas can be communicated, there has to be some stability. And there is a common language or set of symbolic conventions that can be used by artists to fix the meaning of artworks on one level or another. This introduces us to iconography – the study of subjects in art, and their deeper meaning – an important focal point for my discussion of reading art.

In the age of computers we are all familiar with the term icon. But the word has a complex history and this leads me right to the beginning of my consideration of iconography. I want to begin with the juxtaposition of three very different icons: a Byzantine image of the *Virgin and Child* (Fig. 20); Andy Warhol's portrait of the actress *Marilyn Monroe* (1962; Fig. 21); and Mario from *The Super Mario Brothers* game (Fig. 3). In the Byzantine image of the *Virgin and Child* the relationship between text and image is strong. We need to know of the Christian Bible before we see the image of a woman and child as having religious significance. We might identify certain attributes – for instance the Virgin's blue cape or mantel or the fact that the Christ child is holding a scroll, which is a symbol or prefiguration of his death. But how do we know that this image is not just a representation of motherhood or a female figure and child from mythology? In Warhol's *Marilyn Monroe* we see a repeated image of one of Hollywood's best-known stars. This representation of Marilyn Monroe has become so familiar to us, and is so frequently quoted in other artworks, that it has gained an 'iconic' status that is commensurate with the actress herself. Mario, from *The Super Mario Brothers*, speaks to the temporal nature of icons – I am assured that he is more easily recognizable than the *Mona Lisa* to the generations whose interests centre on computer games and virtual reality.

Icon comes from the Greek 'eikon', which means image. In terms of Western art history it is used most commonly to refer to a single image created as a focal point of religious veneration or aid to prayer. The Icon (sometimes spelled Ikon) as a distinct art form grew out of the mosaic and fresco tradition of the early Byzantine period, and the art form has remained largely constant in its appearance throughout its history. An Icon is usually a painted or carved portable object that commonly represents Christ, or the Virgin and Child, in a stiff and somewhat formulaic way, or so it can appear to Western viewers. The anonymous artists who produced these images and those who used them as an aid to devotion or prayer were concerned only with the portrayal of the symbolic or

mystical aspects of the divine being. As such they stand distinct from Western preoccupations with the representation of space and movement as seen in the development of painting from the Renaissance onwards. Although the Icon was in common use by the end of the 5th century CE, the iconoclastic controversy – a debate in the Christian Church about the appropriateness of illustrating the Bible – led to the destruction of many works by those iconoclasts who objected to the practice. But Byzantine Icons continued to be produced in great numbers until 1453, when Constantinople fell to the Ottoman Empire. The art form moved further east to Russia, where Icons were made until the Revolution, and the tradition continues to the present day in Greek Orthodox art.

However, the term icon came to mean 'subject matter' in the 19th-century German school of art history. Icon was initially used by these writers to connote 'image' and this was transposed into 'iconography' – literally the act of writing about images – and 'iconology', the study of images. These fields of art historical enquiry were concerned with the analysis of the visual. As the methods of each approach developed, greater emphasis was placed on the understanding and interpretation of subject matter rather than form.

Both iconography and iconology are important parts of art history. Iconography encompasses the study and interpretation of figural representations, either individual or symbolic, religious or secular; more broadly, the art of representation by pictures or images, which may or may not have a symbolic as well as an apparent or superficial meaning. The term first appeared in the 18th century but was used specifically for the study of engravings, the most common form of book illustration. It soon came to be used to refer more specifically to the history and classification of Christian images and symbols of all sorts, in all media. As we have seen, by the 19th century a far more systematic investigation of art from prehistoric ages to modern times had been established. Through closer inspection and

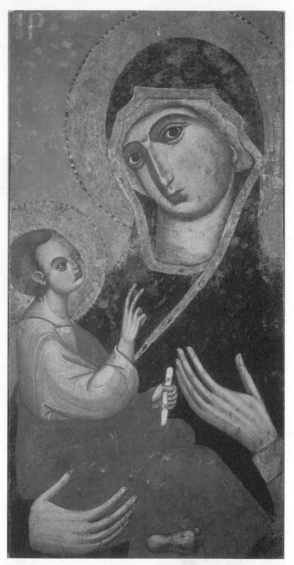

20. Byzantine image of the *Virgin and Child*, School of Venice, 14th century.

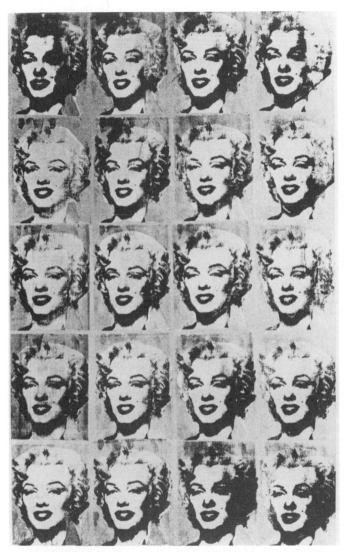

21. Andy Warhol's repeated image of the Hollywood actress, *Marilyn Monroe*, 1962, has gained an iconic status to match that of the actress.

ordering of the visual archive, it became apparent that representational images from different periods and cultures had iconographic traditions of their own. It is not unusual today therefore to find the term qualified to indicate the field under discussion – for example, the iconography of Egyptian deities, the iconography of Roman imperial portraits, Christian iconography, Buddhist or Hindu iconography, and so on.

Iconography is an important method of scholarly investigation as it also enables us to explore the thought from which a given convention of representation has arisen, particularly when the convention has assumed the value of a symbol. In this regard the importance of identifying motifs is an essential part of iconographical interpretation.

Christian iconography is extremely rich and varied and is the kind we encounter most often in Western galleries and museums. Its principal concern is the perils faced by the human soul on earth in its journey towards eternal salvation, and figures from the Old and New Testaments are used to inculcate in every mind the moral aims and fundamental dogmas of the Christian religion. By the time of the Middle Ages, the representation of the stories and characters from the Bible had gone through many transformations and refinements. So in a way we can think of religious art at this time as a kind of sacred 'writing' whose system of characters, I mean here the iconography, had to be learned by every artist – and, indeed, viewer. It was governed also by a kind of sacred mathematics, in which position, grouping, symmetry, and number were of extraordinary importance and were themselves an integral part of the iconographic system.

From earliest times, Christian iconography also operated as a kind of symbolic code, where, for instance, the dove represents the Holy Spirit or a vase of lilies signify the Virgin's purity in the representations of the Annunciation. Saints also have attributes that help us to recognize them. For instance, St Catherine of

Alexandria is traditionally portrayed in the presence of a wheel. This wheel, as her attribute, serves to identify her and at the same time signifies a miracle connected with her martyrdom. It must be said, however, that the conventions and symbols, as well as their meanings, change with the passage of time and the growth of ideas; many disappear, while others become almost unintelligible to subsequent generations and can be recovered only by intensive study. Leading on from this iconology is the study of the meaning contained within the symbols in a particular work of art. For example, in Christian art the figure crucified upside-down is a reference to St Peter, as he considered himself unworthy to die in the same manner as Christ. In this way the image represents the Christian faith, and St Peter's own faith and humility.

Iconography and iconology are, then, two modes of visual analysis or reading pictures that derive from the word icon. Traditionally, these symbols derive from a readily recognizable, common currency of cultural or religious experience. Among the foremost scholars in this field of art history are Émile Mâle, Aby Warburg, and Erwin Panofsky, all of whom have written extensively on the ways in which we can read art. But reading images in this way is not confined to Christian art, or indeed the art of the past.

The 17th-century Dutch artist Vermeer used many symbols, attributes, personifications, and allegories to give his secular paintings iconographical meaning. His *Maid with a Milk Jug* (Fig. 16), painted around 1658–60, is a useful example not only for reading meaning but also to show how technical analysis into the physicality of the object can reveal important changes that were made by the artists in the evolution of the composition of the painting. Technical investigations, including X-ray and close examination of the paint surface, into this small oil painting (it measures 45.5 × 41 cm) have shown that Vermeer removed several details to create a starker contrast between the subject and the background of this work. For instance, pentimenti show us that there was a map or a painting on the wall behind the milkmaid and

a laundry basket where we now see a foot stove. There are compositional reasons why these changes were made. But closer investigation of the iconography of the picture perhaps tells us a little more.

Firstly, it is important to ask why Vermeer replaced the laundry basket – it clearly refers to the duties of a kitchen maid. Yet, Vermeer chose to replace the laundry basket with a foot stove, which does not seem to relate so closely to the domestic role of a kitchen maid. If we want to look beyond the 'face value' of these images, other evidence of the culture and society of the time may be useful. In the case of Vermeer, we can turn to Emblem books, known as *Embleemboek* in 17th-century Holland. These illustrated volumes tell us the meaning of these apparently everyday objects, which is often derived from or related to their function. Hot coals were put inside a foot stove to provide much-needed heating in the cold winter months. As an emblem the foot stove can then be seen as a symbol for warmth, love, and loyalty. This symbolic meaning becomes even clearer when we look at the background of the picture. There are some tiles decorated with small Cupids which also refer to love and warmth. It is unclear whether this refers to the fact the milkmaid is in love herself, but by looking at the iconographic images in this picture we can begin to see it as more than just a genre scene.

Iconology is not just a means of reading the art of the distant past – it can also help us to understand the symbolic meaning of recent art. For instance, the Washington Monument is a symbol of the American state. Its obelisk form refers to the authority of ancient Egypt and Rome and is a potent symbol of a newly formed country, government, and capital city. This image was subverted, as a protest against the Vietnam War, by the artist Claes Oldenburg in his sculpture *Lipstick*. Here Oldenburg transformed the obelisk into a deflatable, brutally absurd instrument of war. Oldenburg was part of the Pop Art movement, which was mainly concerned with the use of popular imagery

and symbols from everyday life, and gives us another way of reading art.

Pop Art first appeared in the late 1950s and flourished in the 1960s and early 1970s and uses the imagery and techniques of consumerism and popular culture. It developed primarily in Britain and the United States as a reaction against Abstract Expressionism, where it was linked to the wealth and prosperity of the post-World War II era and the American consumer society. The movement eliminated distinctions between 'good' and 'bad' taste and between fine art and commercial art techniques. Pop artists employed a common figurative imagery found in comic strips, soup cans, and Coke bottles to express formal abstract relationships. By this means they provided a meeting ground where artist and layman could come to terms with art. Incorporating techniques of sign painting and commercial art into their work, as well as commercial literary imagery, pop artists such as Roy Lichtenstein and Andy Warhol attempted to fuse elements of popular and high culture to erase the boundaries between the two. If here we think back to Vermeer's use of everyday objects as 'signs', it becomes clear that our ability to 'read' images is culturally and temporally determined. The everyday objects of the middle-class merchants of 17th-century Holland are less familiar to us than those of the 1950s and 1960s. But this does not mean that Vermeer is any less evocative or effective in representing ideas than his 20th-century counterparts.

The methods of representation used by Warhol and Lichtenstein vary considerably but are both based on the techniques of mass reproduction used by the consumerist society they set out to critique. Andy Warhol is known for his silkscreens of both famous people and everyday objects, while Roy Lichtenstein employed a comic strip style in his paintings and manipulated those illustrative techniques to great aesthetic effect. As a visionary, Andy Warhol's work anticipated a world where a consumer-driven culture came to value the brand name and iconic item above

individuality. Warhol chose his imagery from the world of commonplace objects such as dollar bills, soup cans, soft-drink bottles, and soap-pad boxes. He is variously credited with attempting to ridicule and to celebrate American middle-class values by erasing the distinction between popular and high culture. Monotony and repetition became the hallmark of his multi-image, mass-produced silkscreen paintings. Many of these, such as the portrait of Marilyn Monroe, were based on newspaper photographs. Marilyn Monroe became a world-famous sex symbol and a Hollywood legend after her suicide at the age of 36 in 1962 – the same year as Warhol's portrait. Through his technique and method of representation, Warhol comments on the commodification of the actress and the potency of mass-produced images.

The reality of the representation of Marilyn Monroe exists partly in the use of a photograph as the basis of the image. But the truth or objectivity of the mechanically reproduced image is as vulnerable to the particularity of the artist's imagination as any illustration of textual material and we must not forget it is an artwork in its own right. For instance, the early photographer Man Ray comments on the 'verisimilitude' of the image in his *Le Violon d'Ingres* (Fig. 22). Here we are presented with a female nude seen from behind. The pose and headdress make reference to Ingres's nudes, especially his voluptuous bathers. Ingres's realistic handling of paint is echoed in the realism of the photographic print. But Man Ray plays with our readiness to accept that which we see as real, as the shape of the woman's back also represents a violin. Who is playing or can play with whom?

The ambivalent relationship between art, artist, and viewer is true of virtual reality – a computer-generated environment with and within which people can interact. *The Super Mario Brothers* uses virtual reality as part of an electronic game where a computer programme synchronizes a variety of sounds with the movie-like animated action portrayed on a graphic display. Whatever the

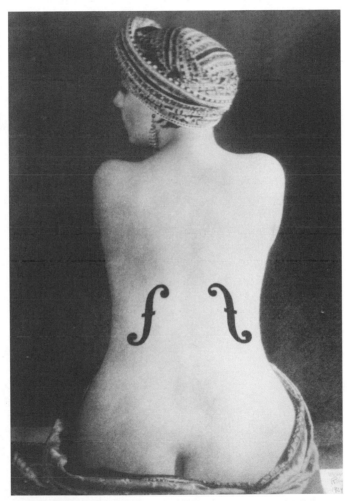

22. Man Ray's gelatin silver print of a woman, *Le Violon d'Ingres* (1924), makes references to Ingres's nudes in the model's pose and headdress, as well as to the form of a violin.

technical wizardry of the game, just like other forms of representation it is created by humans for other human viewers. In other words, whether we are looking at a Byzantine Icon; a 17th-century Dutch genre picture; Pop Art; a photograph or computer animation, it is the interaction between viewer and object that gives art its meaning and decides the way in which the visual is read.

Chapter 6
Looking at art

The physical properties of artworks have an important influence on how we understand them as objects. I want here to outline some examples of the different media and techniques of producing art, to show how an awareness of these factors can help our understanding of art history. Each example acts as a kind of vignette to show how the physical properties of an artwork can add another layer of meaning to its history. The discussion of the technical aspects of each technique is backed up by the glossary of terms at the end of the book. This should also be a useful guide for looking at works in galleries or museums.

Sketches and drawings

We often find the preparatory processes behind a work of art as enigmatic as the work itself. One such example is Leonardo da Vinci's *The Virgin and Child with St Anne and St John the Baptist* (Fig. 15), which dates from around 1500. This large drawing or cartoon executed in charcoal and black and white chalk on tinted paper is a full-size preparatory study for a painting. It has, however, never been used to transfer a design onto a panel and this is why it survives. In order to transfer the composition onto the picture surface, the outlines would either have been pricked with a pin and then the drawing covered in soot to leave a dotted outline, or the outlines would be scored through, leaving incisions on the surface

to be painted as a guide to the artist. Both these techniques entailed the destruction of the preparatory drawing. It is possible that Leonardo's cartoon was preserved as a work of art in its own right, although some areas are deliberately left inconclusive or in rough outline. The pretext for the drawing is likely to have been a commission for a painting given to Leonardo by King Louis XII of France. Leonardo started work on this painting in about 1508. It was unfinished at his death and is now in the Louvre in Paris. The composition is different from the cartoon, so perhaps Leonardo changed his mind at the last moment.

During the Renaissance period, paper became more readily available and as a result some preparatory drawings have survived (previously artists used re-usable surfaces for these). Coloured papers were often used as a middle tone for drawing by early artists. The papers used could be brown, grey, green, or pink, but blue was the most common. These colours easily made their way onto canvas, where they served the same purpose in designing the values of an image. The experiments with tonal values that drawing with chalk, charcoal, and coloured paper facilitated influenced the work of many artists. For instance, in the executed version of *The Virgin and Child with St Anne and St John the Baptist*, Leonardo painted in fine, translucent glazes with the underdrawing showing through in some areas; it represents a culmination of his research into aerial perspective, which Leonardo codified in his notes for the *Treatise on Painting* (1490–5).

Although we now accept drawings as works of art in their own right, up until very recently they remained merely preparatory processes – no matter how detailed and complex they might be. The striking line drawings of Matisse or Picasso are among their most popular works, whereas the sketches of earlier artists are far less well known. The fragility of drawings does mean, however, that few are on permanent display (the Leonardo cartoon is a notable exception), and they require subdued lighting and controlled conditions to ensure no damage occurs. So it is also partly the

nature of the materials and technique that has led to the lack of prominence of drawings in art historical writing and exhibitions.

Tempera painting

One of the oldest mediums of painting is egg tempera. It was used by the ancient Egyptians and Greeks and the icon painters of the Byzantine Empire – indeed the Orthodox Church never broke with the tradition and still uses egg tempera today. The paint is made from finely ground dry pigments, and the standard medium is pure egg yolk, free from white, which would cause the paint to dry more rapidly and to drag on application. Water can be used to dilute the mixture. Once the paint has been made it cannot be stored, so it was important for artists to make only enough for a particular painting session – especially if they were using expensive pigments. When completely dry, tempera paint is relatively water-resistant.

The support is usually a soft wood such as poplar or basswood. Tempera paint requires a slightly absorbent ground, or base, because of the relatively weak binding strength of the egg. The usual chalk gesso ground that gives the smooth surface on which to apply the paint is relatively inflexible and requires a rigid support.

The mixture of pigment and yolk is diluted with water and applied thinly. Impasto, or textured, effects are not possible as the paint would crack and peel off. Instead, the paint surface is very flat and the tonal values of the pigments remain largely unmodulated in each application of paint. For this reason, it can be seen that the use of tempera in the representation of the *Virgin and Child* (Fig. 20) is in keeping with the purpose and aesthetics of Byzantine icons. The stiffness of the image is not due to lack of artistic ability or the limitations of technique – just a different set of priorities. However, underpaint could be used to achieve modelling and tone, for instance a green underpaint was used for flesh – this has often worn away with time, resulting, for example, in many faces painted in

tempera having a greenish tinge that now looks very unnatural. White could be mixed with the colour and applied in successive or adjacent applications, so making it possible to achieve relatively naturalistic representations of drapery, with the darkest tone of the pigment providing the shadows.

Egg tempera was also a popular medium for the artists of the Early Renaissance in Italy. The technique was described in great detail by the Early Renaissance artist Cennino Cennini in his *Craftsman's Handbook* (1437). This was translated into English in 1899 by Christiana J. Herringham, which prompted a revival of interest in the technique, and tempera remains in use today.

Oil painting

Oil painting involves mixing pigment with drying oils – commonly linseed oil, which acts as a varnish to seal pictures and protect them from water. From as early as the 13th century, oil was used for painting details over tempera pictures. Cennino Cennini discusses the use of oil paint, indicating that it was known about in Italy but was not widely used at that time.

The perfection of oil painting is usually ascribed to the Flemish Van Eyck brothers who were working in the first half of the 15th century. The technique was then introduced by Antonella da Messina to Italy, where it received an enthusiastic reception. Whatever the truth in these stories, it does appear that oil painting began in northern Europe and was influential in the development of painting in the Italian Renaissance. This important influence of artists working north of the Alps on their southern counterparts prompts us to rethink the view of the Renaissance as being solely about Italy's rediscovery of its Classical past. It seems the interest in naturalism and the effects of light and shade, which preoccupied artists such as Leonardo, was enabled through the adoption of northern techniques of painting rather than by the art of antiquity.

By the 16th century, the new medium of oil painting had in fact succeeded tempera, as it offered far greater possibilities for artistic experimentation. Some artists continued to use oil and tempera in the same work, exploiting the different qualities of each technique for the best effect. Oil remained the dominant medium for painters up until the introduction of acrylic paints in the 20th century.

The main supports used for oil painting are wood and cloth, both prepared with a ground. A preparatory drawing, or cartoon, was then transferred onto the ground, or sometimes artists drew directly on this surface using black or red chalk. This preliminary design mapped out the principal elements of the composition. After this, an imprimatura base was applied to the entire picture surface, which affected the tonal value of the whole depending on the colour chosen. For example, a neutral tone such as light grey or brown could function as the mid-point in tonal values and could be used to create half-tones, shadows, or backgrounds. We can see this in the work of Vermeer who used mainly light grey to light brown grounds – these are evident in *Maid with a Milk Jug* (Fig. 16). By contrast, Velázquez preferred light grey and off-white layers; this helps create the interesting light and space of *Las Meninas* (Fig. 6).

The imprimatura was followed by the blocking out of basic colours, upon which finer and finer detail was added. The oil process enabled a softening and blending of colours. Paint was either blended to a polish, as in Van Eyck's works, or else it was painted freely, like Rembrandt's. Indeed, in the 17th century, spontaneity of brushwork ('painterliness') was much admired in the work of Velázquez, and we have already seen in Chapter 1 how this technique appealed to the Impressionists. A final layer of varnish was added to protect the paint surface from dirt, abrasion, and water.

The preparatory processes of academic art – the oil sketch or alla prima painting, sometimes known as *esquisse* and *ébauche* – became standard techniques of Impressionist artists and their

successors. Monet's painting of *Rouen Cathedral* (Fig. 1) is an excellent example even though it was produced quite late in the artist's career. The looser quality of the handling of the paint and the play on texture and light made art appear more visually accessible, despite there being more for the viewer to 'complete' in terms of recognizing what is being represented. In recognition of the quickness of this new technique, which enabled artists to capture light effects so much more effectively, Monet painted several images of the cathedral at different times of day – to show how objects change under various lighting and atmospheric conditions. The unfinished look of these works shocked the Academy at the time, but this development in technique and mode of representation was a cathartic moment in Western art.

Sculpture: modelling, carving, and casting

Sculpture is the art of producing in three dimensions representations of natural or imagined forms. It includes sculpture in the round, which can be viewed from any direction, as well as incised relief, in which lines are cut into a flat surface. Sculpture has been a means by which ideas could be expressed since prehistoric times. We know little about prehistoric artefacts, but we are certain that the ancient cultures of Egypt and Mesopotamia produced large numbers of sculptures, which were often monolithic. These works were used in religious rituals as well as admired for their aesthetic beauty. Similarly, in the ancient Americas and in Asia, sophisticated techniques and styles were used to produce symbolic sculptures.

The beginnings of the tradition of European sculpture is found in the freestanding and relief work of the ancient Greeks, which may well have been influenced by Egyptian art. By the time of the Classical and Hellenistic periods, the representation of the intellectual idealization of its principal subject, the human form, was a predominant concern. The concept was so magnificently realized by means of naturalistic handling that it became the inspiration for centuries of European art. We have seen this, for

instance, in the *Apollo Belvedere* (Fig. 7), a Roman copy of a Greek original that exemplifies the artistic preoccupations of the time and the influence the Greeks had on subsequent traditions. Sculpture encompasses a range of techniques, including modelling, carving, and casting. Each of these helps give the finished work a distinct character or aesthetic. For instance, modelling in a medium such as clay or wax permits the addition as well as subtraction of material and is highly flexible. The ancient technique of firing of clay from simple terracotta to elaborately glazed ceramics has produced some striking works that are geographically and temporally dispersed. By contrast, carving, from such varied materials as stone, wood, bone, and, more recently, plastics, is strictly limited by the original block from which material must be subtracted. It is not unusual for sculptors to add separate pieces of the same or different material that are mechanically joined to the main block. Rodin's *The Hand of God* (Fig. 19) shows how the subtractive process of carving works to gradually 'reveal' the figure. The marks of the chisel and claw hammer can still be seen on the marble, showing how the carving process was one of gradual refinement to the smooth polished finish of the hand.

Casting is a reproduction technique that duplicates the form of an original whether modelled, carved, or constructed, but it also makes possible certain effects that are impractical with the other techniques. Top-heavy works that would require external support in clay or stone can stand alone in the lighter-weight medium of hollow cast metal.

The tensile strength of bronze allows for a great deal of freedom in the composition of works. The Greeks excelled in bronze sculpture, as seen in the few surviving examples of their work, for instance *The Zeus of Artemisium* in the National Museum in Athens and *The Delphic Charioteer* in the Museum at Delphi. Returning to the *Apollo Belvedere*, we can see how copying a bronze work in another material – in this case marble – demonstrates the different qualities of the materials. This is not just in terms of the composition but the

overall effect: the serene white of the marble (in which medium most ancient Greek sculptures are now known) would have contrasted with the Greek original in shiny bronze, perhaps partially draped with real cloth and garlands of flowers. The Greeks, and the Chinese, mastered the cire perdue ('lost wax') process of bronze casting. Italian Renaissance sculptors revived bronze casting skills, as seen in Lorenzo Ghiberti's doors to the Baptistery of San Giovanni in Florence, known as the *Gates of Paradise*. The classic description of Renaissance bronze casting is given in Benvenuto Cellini's *Autobiography* (1558–62).

How technical knowledge informs art history

This very brief survey of some of the techniques used in the production of artworks shows that artists are not always confined by the medium in which they work. Important choices are made that stand outside the constraints of the materials and techniques. It is necessary that we understand the techniques and processes used by artists, and the glossary develops this further. But it is also essential that the interface between the qualities of medium and technique and the aesthetic decisions made by the artist is clearly understood. By achieving this understanding, the ways of thinking about, writing about, presenting, and reading art history remain engaged with the work rather than operating at a distance from it.

References

Chapter 1

Judy Chicago, *The Dinner Party* (Penguin, 1996).

Chapter 2

Jacob Burckhardt, *The Civilisation of Renaissance Italy* (1860); modern edn. tr. S. G. Middlemore (Phaidon, 1961).

Ernst Gombrich, *The Story of Art* (1950); 16th rev. edn. (Phaidon, 1995).

Linda Nochlin, 'Why Have There Been No Great Women Artists?' (*Art News*, Jan, 1971); reprinted in Linda Nochlin, *Women, Art and Power*, (New York: Harper and Row, 1988), pp. 145–177.

Pliny the Elder, *Natural History* (CE 77); modern edn. *The Elder Pliny's Chapters on the History of Art*, tr. K Jex-Blake (Chicago: Ares, 1976).

Griselda Pollock and Rozsika Parker, *Old Mistresses* (Routledge and Kegan Paul, 1981).

Giorgio Vasari, *Lives of the Artists* (1550, 1568); modern edn. *The Lives of the Artists*, 2 vols, tr. George Bull (Penguin, 1987).

Johann Joachim Winckelmann, *Imitation of the Painting and Sculpture of the Greeks* (1755); modern edn. *Reflections on the Imitation of Greek Works in Painting and Sculpture*, tr. Elfriede Heyer and Roger C. Norton (Open Court, 1987).

Chapter 4

Alexander Gottlieb Baumgarten, *Aesthetica* (Georg Publishers, 1986).

Jacques Derrida, *The Truth in Painting* (1978).

Immanuel Kant, *Critique of Judgement* (1790).

Chapter 5

Émile Mâle, *Religious Art in France: the Late Middle Ages: a Study of Medieval Iconography and Its Sources* (Princeton University Press, 1992).

Erwin Panofsky, *Studies in Iconology: Humanistic Themes in the Art of the Renaissance* (Westview Press, 1972).

Aby M. Warburg, *Images from the Region of the Pueblo Indians of North America*, tr. Michael P. Steinberg (Cornell University Press, 1995).

Chapter 6

Benvenuto Cellini, *Autobiography*, tr. by George Bull (Penguin, 1999).

Cennino Cennini, *Craftsman's Handbook*, tr. Christiana J. Herringham (Allen and Unwin, 1899).

The Notebooks of Leonardo da Vinci, ed. Irma A. Richter (Oxford World's Classics, 1998).

Further information

Selected American and European art museum websites

Metropolitan Museum, New York www.metmuseum.org

Museum of Modern Art, New York www.moma.org

Whitney Museum of American Art, New York www.whitney.org

International Center for Photography, New York www.icp.org

Dia Center for the Arts, New York www.diacenter.org

Brooklyn Art Museum, New York www.brooklynart.org

Guggenheim Museum, New York, Bilbao, Venice, Berlin, Las Vegas
www.guggenheim.org

Smithsonian Institution, Washington DC www.si.edu

National Gallery of Art, Washington DC www.nga.gov

National Museum of American Art, Washington DC www.nmaa.si.edu

Yale Center for British Art, New Haven, Connecticut www.yale.edu/
ycba

Sterling and Francine Clark Institute, Williamstown, Massachusetts
www.clarkart.edu

Philadelphia Museum of Art, Pennsylvania www.philamuseum.org

Boston Museum of Fine Arts www.mfa.org

Andy Warhol Museum, Pittsburgh, Pennsylvania www.warhol.org

Art Institute of Chicago www.artic.edu

Museum of Contemporary Art, Chicago www.mcachicago.org

Walker Art Center, Minneapolis, Minnesota www.walkerart.org

Contemporary Arts Center, Cincinnati, Ohio
www.contemporaryartscenter.org

Denver Art Museum www.denverartmuseum.org

San Francisco Museum of Modern Art www.sfmoma.org

Berkeley Art Museum and Pacific Film Archive, California
www.bampfa.berkeley.edu

J. Paul Getty Museum, Los Angeles, California www.getty.edu/museum

Museum of Contemporary Art, Los Angeles www.moca.org

Tate Gallery, London www.tate.org.uk

National Gallery, London www.nationalgallery.org.uk

British Museum, London www.thebritishmuseum.ac.uk

Louvre, Paris www.louvre.fr

Musée d'Orsay www.musee-orsay.fr

Centre Pompidou, Paris www.cnac-gp.fr/english

Altes and Pergamon Museums, Berlin www.smpk.de/ant/e/s.html

Stedelijk Museum of Modern Art, Amsterdam www.stedelijk.nl

Van Gogh Museum, Amsterdam www.vangoghmuseum.nl

Museo del Prado, Madrid www.mcu.es/prado/index_eng.html

Uffizi Gallery, Florence www.uffizi.firenze.it

Other art history websites include:

a site developed and maintained by Sweet Briar College, Virginia:
http: //witcombe.bcpw.sbc.edu/ARTHLinks.html

and the Mother of All Art and Art History Links Webpage from
the Art History Department at the University of Michigan:
http://www.art-design.umich.edu/mother

Glossary

Words in *italics* denote headings of related entries in the glossary

alla prima painting: painting, usually from life, in a direct manner: completing a painting in a single session or while the paint is still wet. It was originally a means of oil sketching, but was adopted by the Impressionists to produce finished works of art painted outside the artist's studio.

bronze: bronze is ideal for casting artworks; it flows into all crevices of a mould, thus perfectly reproducing every detail of the most delicately modelled sculpture. It is malleable beneath the graver's tool and admirable for *repoussé* work.

canvas: a *support* for a painting made from woven flax and stretched over a frame.

carving: carvers have for centuries used many types of hammers, chisels, drills, gauges, and saws. For carrying out monumental works from small studies, various mechanical means have been developed for approximating the proportions of the original study.

chiaroscuro: a method of painting that represents sharply contrasting lighting, usually drawing *highlights* out of a dark scene. The term can also refer to an element of this effect in any picture. This technique was first seen in the work of Leonardo da Vinci.

cire perdue: also called 'lost wax', a method of casting *bronze* using a clay core and wax coating placed in a mould. The wax is melted in the mould and drained away, and molten bronze is then poured into the

space that is left, producing a hollow bronze sculpture once the clay core has been removed.

gesso: in Spain and Italy, this was gypsum (calcium sulphate) mixed with animal glue and applied as a *ground* to a wood substrate. In northern Europe, a similar ground of chalk (calcium carbonate) was used in a glue binder. A first, coarse layer, known as gesso grosso, was applied, followed by a smooth top layer called gesso sottile, which could be polished to a fine finish. Some later artists applied only one layer of gesso sottile.

glaze: a film of transparent colour laid over a dried *underpainting*. This technique is common in the work of artists such as Titian and Rubens.

grisaille: monochromatic painting, usually in various tones of grey, that can give the effect of a stone sculptured relief. The term also refers to the *underpainting* of a work, where local colour is applied over the grisaille as opaque, semi-opaque, or transparent colour.

ground: the primary surface on to which colour is applied. It usually refers to an opaque coating rather than the *support*. Traditionally, ground is an opaque white oil priming on canvas, or chalk or gypsum mixed with animal glue (see *gesso*) on wood panel.

highlight: the lightest *tone* in a painting.

impasto: painting thickly with a bristle brush or palette knife in order to create surface texture. The term is often used to describe the technique of Impressionist painters, but also seen in the work of Rembrandt.

imprimatura: an oil *ground*, often of a neutral or pale *tone*, used as a base coat in oil painting.

lapis lazuli: a very expensive, dense blue pigment made of ground lapis lazuli – a semi-precious stone.

medium: a liquid additive used to apply pigments as paint, for example linseed oil or egg yolk (see *tempera*). Choice of medium influences drying time and the elasticity of paint film when dry.

modelling: in painting, indicating the three-dimensional form of an object through different *tones* – sometimes referred to as modelling in colour; or creating the illusion of volume by painting the effects of light and shadow on form – sometimes referred to as modelling

in light and shade. In sculpture, the term denotes a technique involving the use of a pliable material such as clay or wax. The technique is exemplified also by those works in cast metal and plaster that are made from the mould of a clay original. The mould is made by the process of *cire perdue*.

palette: the implement – usually a flat board held in one hand – upon which a painter holds or mixes his or her colours, or a selected assortment of colours chosen for use in a painting technique. 'Limited palette' refers to an artist's use of a restricted number of colours or *tones*.

paper: coloured papers (the most common being brown, grey, green, pink, and blue) were often used as a middle tone for drawing by early artists. Leonardo and others executed value studies on blue linen known as 'linen from Rheims'.

parchment: also called vellum, calf-skin that has been dehaired, stretched, and scraped, then prepared with chalk and pumice stone and stretched over a wood *support*.

pentimento: the visibility of line or colour through the increasingly transparent overpainting which was originally used to conceal it. This reveals where artists changed their compositions.

prime: to cover a surface (*support*) with a preparatory coat of colour: a first coat or layer of paint, *size*, etc. given to any surface as a base or sealer. The term 'primer' is often used to describe a pigment and oil *ground* applied to cloth such as canvas or linen.

relief: in sculpture, three-dimensional projection from a flat background. In alto-relievo, or high relief, the protrusion is great; basso-relievo, or bas relief, protrudes only slightly; and mezzo-relievo is intermediate between the two.

repoussé: of metalwork, hammered into relief from the reverse side.

scumbling: scraping, scrubbing, or dragging a thin layer of lighter opaque or semi-opaque colour over a dark *underpainting* with a bristle brush, allowing the underpainting to show through. This technique was used by Constable and Turner to create cloud effects in their landscape views.

size: a gelatinous or glutinous preparation made from glue or starch used for filling the pores of cloth (usually canvas) or paper *support*, or

as an adhesive *ground* for gold leaf on books. In painting, it is used to seal the support's surface to protect it from acid and make it less absorbent.

support: the material on to which *size*, paint, etc. is applied. A support may be inflexible or flexible. The usual material for inflexible supports is wood panel, which can be made of many woods, including poplar, oak, and mahogany. Multiple panels glued together tongue-in-groove with grains running in opposing directions make better supports than one solid board, which is more likely to bow and warp. Flexible supports are made of cloth or paper. Cloth, most usually linen, canvas is made from flax and stretched over a frame or panel. Cloth is the weakest point in the survival of a well-made picture, but its light weight, transportability, and possibility for easy repair make it an enduring choice.

tempera: a method of painting with pigments dispersed in an emulsion and thinned with water. Fresh egg yolk is the most common traditional *medium* for tempera painting. Tempera was used in ancient Egypt, Greece, and the Byzantine Empire, and in Europe in medieval times and the early Renaissance for fine painting; it began to give way to oils in the 15th century.

terre verte: a very light transparent green pigment traditionally employed for *underpainting* flesh.

tone: the degree of lightness or darkness of a colour.

toned ground: colour mixed with white as a primer to provide a uniform opaque *ground*.

underpainting: preliminary painting, often sketching out the composition, usually monochrome, or blocking out areas of colour, over which successive layers of colour are added.

varnish: protective surface film imparting a glossy or matt surface appearance to a painting, usually applied to the finished work. *Glazes* were sometimes added after this stage.

vellum: see *parchment*.

verdaccio: greenish *underpainting* often used in *tempera* (see *terre verte*).

Index

Visit the
VERY SHORT
INTRODUCTIONS
Web site

www.oup.co.uk/vsi

➤ **Information** about all published titles

➤ News of **forthcoming books**

➤ **Extracts** from the books, including titles not yet published

➤ **Reviews** and views

➤ **Links** to other **web sites** and main OUP web page

➤ Information about **VSIs in translation**

➤ **Contact** the editors

➤ **Order** other **VSIs** on-line